IMAGES
of Rail

ELECTRIC TROLLEYS OF WASHTENAW COUNTY

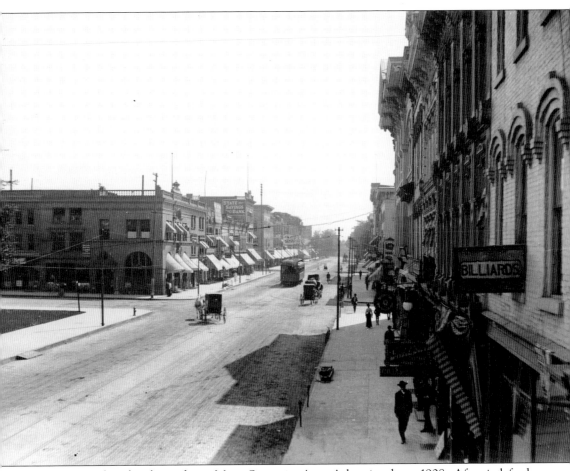

An interurban heads south on Main Street in Ann Arbor in about 1908. After it left the interurban station a half block west on Huron Street, it took the curved track onto Main Street. A corner of the county courthouse lawn is seen on the left. The building with the large arch window on the northeast corner of Main and Huron Streets is the Farmers and Mechanics Bank building. It was smashed by a runaway train of interurban freight cars in 1927. (Bentley Historical Library HS1708.)

IMAGES
of Rail

ELECTRIC TROLLEYS OF WASHTENAW COUNTY

H. Mark Hildebrandt and
Martha A. Churchill

ARCADIA
PUBLISHING

Published by Arcadia Publishing
Charleston SC, Chicago IL, Portsmouth NH, San Francisco CA

Printed in the United States of America

Library of Congress Control Number: 2008941223

For all general information contact Arcadia Publishing at:
Telephone 843-853-2070
Fax 843-853-0044
E-mail sales@arcadiapublishing.com
For customer service and orders:
Toll-Free 1-888-313-2665

Visit us on the Internet at www.arcadiapublishing.com

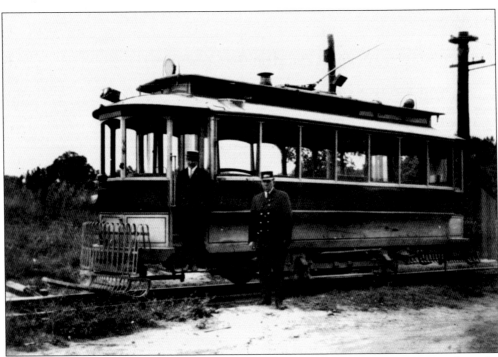

At the west end of the Packard-Huron streetcar line in Ann Arbor, the motorman stands on the steps, and the conductor stands beside the trolley. The telephone booth to call the dispatcher is at the foot of the telephone pole to the right. This type of car was locally called a "dinky" to distinguish it from the large interurban cars. It was built before 1900. (Bentley Historical Library HS3167.)

CONTENTS

ACKNOWLEDGMENTS

We wish to thank the numerous people who helped us with photographs and information. Here are some of them, in no particular order: Tom Diab of the Chelsea Area Historical Society; Gerry Pety, archivist, and James Mann, historian, at the Ypsilanti Historical Society; Grace Shackman of Ann Arbor; Jack Schankin at the Petersburg Library Historical Room; Robert Lane of the Saline Area Historical Society; George B. Sparrow of Chelsea; Henry F. Burger of Riverview for his help with the Petersburg line; Robert D. Shannon of the Chelsea Area Historical Society; Bill Bond of Ann Arbor and Mary Lou Slater of Ann Arbor for their photographs of the Ann Arbor Trolley and Museum; Ken Baumann of Milan; Robert Pratt of Milan; Tom Preston of Milan; Chris Kull, archivist, at the Monroe County Historical Museum; Rev. Vernon Campbell of Milan; Wystan Stevens of Ann Arbor; the Bentley Historical Library, including the Sam Sturgis and Claude Stoner Collections and the Hazel Proctor Collection; McKune Public Library, Chelsea; the Milan Area Historical Society; and the Pittsfield Township Historical Society Web page. Images not otherwise credited are from the collection of H. Mark Hildebrandt.

INTRODUCTION

The era of the interurban electric railway, 1890–1930, is illustrated in this book. It follows the rise and fall of the electric railway lines in Washtenaw County in the southeast corner of Michigan. Washtenaw County has ties to both metropolitan Detroit directly to its east and rural communities. Ann Arbor, its county seat, is the site of the University of Michigan. Ypsilanti, seven miles east of Ann Arbor, contains Eastern Michigan University, originally Michigan State Normal College. Chelsea, Milan, and Saline, also chapters in the book, are smaller communities with shopping districts and some manufacturing that have thrived to the present.

The earliest urban public vehicles were cabs or cabriolets, horse-drawn vehicles that were available for hire to individuals. The omnibus (the origin of the current term *bus*) was a horse-drawn vehicle accommodating a number of passengers. Each person paid a fare, and the omnibus had a franchise to operate on a fixed route. It was an obvious development to mount the omnibus on steel wheels on rails to reduce friction. The horsecar was born. However, the horsecar suffered several disadvantages. Horses were subject to fatigue, requiring replacement every four to six hours. They had a short useful life of three or four years. Epidemics of disease could wipe out the entire stable. Of course, the problem of smelly manure and urine in the street was also undesirable. In 1880, cable cars were introduced. A steam engine in a central powerhouse drove the cable, which ran continuously under the street along pulleys. The cable then was gripped and ungripped by the gripman. Cable cars became obsolete with the introduction of an electric motor to power the axle of a horsecar in 1888. Although cable railways were still built after 1890, the electric street railway became universal in cities and towns in the next 20 years. Electricity was generated in a central powerhouse and delivered to the car by an overhead trolley wire. Early streetcars drug a "troller" or trolley along the wire and were naturally called trolleys. The rigid trolley pole with a wheel to connect to the trolley wire became standard. The term *streetcar* was used in the Midwest for the local street railway car. *Trolley car* was more common on the East Coast. Early streetcars, like horsecars, rode on four wheels.

The first extensions of the street railway out of town were powered by a small steam engine encased in a streetcar body, or dummy engine. This was to prevent scaring horses who sometimes bolted when they saw an exposed steam engine rolling down the street with pistons whirring. A runaway horse was dangerous to the driver, the wagon, and the passengers. An interurban railway describes a streetcar line that was extended out of town to another town. Instead of going down the middle of the street or road, it was built along the side of the road or along a railway line. The interurban provided frequent service at twice the speed of a horse and buggy and was able to stop at each road crossing. The interurban car was commonly double-trucked; that is,

there was a set of four wheels or a truck under each end of the car body, resembling a steam railway passenger car. They were very popular because they were perfect for country-to-town or town-to-city travel.

Early interurbans required a power station every 30 miles, since the standard 600-volt direct current (DC) power for the motor would lose voltage over more than 15 miles. However, 5,000 to 22,500 volts alternating current (AC) could be carried many miles from a single large power-generating station and delivered to the trolley wire through substations every 15 or 20 miles. The substation reduced the voltage to 600 volts and converted the AC to DC.

The interurban electric railways built inexpensively along existing roads or railroads, successfully competing with the steam railroad lines by providing lower fares, frequent service, and local stops at crossroads. They provided convenient rapid access to regional cities from small towns and offered package express service. On many lines, there was daily milk collection along their routes so that central dairies could process and deliver fresh milk each day.

The decline of the electric interurban was a result of the rapid increase in automobile ownership as mass production reduced the cost of motorcars. In addition, the use of public money to pave the principal routes between towns made it possible for bus companies to compete without owning the highway. The interurban companies were private businesses that owned the tracks and land they operated on. The land was taxed by the towns and counties they traversed. Not only did the taxes they paid underwrite the improvement in the roads they paralleled, but the resulting increased automobile ownership reduced the demand for interurban and streetcar service.

As highways have become more crowded, there is greater need for rail alternatives, either diesel railcars or electrified lines served with light-rail cars, which used to be called trolleys. Those that have survived or been built in the last several years require public funding through regional transit authorities that receive property tax support. Maybe residents will again travel on rapid transit rails, a resurrection of the interurban trolley in Washtenaw County.

However, trolleys are not dead, but are reviving in other parts of the country and in some parts of the world are thriving. The last surviving interurban in this country is the Chicago, South Shore and South Bend Railroad, or South Shore Line. It survives thanks to the subsidy by the regional transit authority. Operation by a transit authority makes it eligible for national government funding to decrease highway congestion. Streetcars are still operating in regular service in Boston, Philadelphia, New Orleans, Toronto, and San Francisco. Light-rail lines, operating mostly off the street, have been built in San Diego; Portland, Oregon; Denver; Dallas; Salt Lake City; Sacramento; and Baltimore.

For a list of operating trolley, tram, subway, and interurban lines worldwide, visit the Light Rail Transit Association Web site.

Year	Timeline of Trolleys in Washtenaw County
1890	The first electric streetcars were operated in Ann Arbor by the Ann Arbor Street Railway.
1891	The Ann Arbor and Ypsilanti Street Railway connected the two towns using a steam-dummy engine to pull one or two passenger cars and provided service every two hour.
1896	The Ann Arbor and Ypsilanti Electric Railway was incorporated to electrify the Ann Arbor and Ypsilanti Street Railway and absorbed the Ann Arbor Street Railway.
1897	The Detroit, Ypsilanti and Ann Arbor Railway absorbed the Ann Arbor and Ypsilanti Electric Railway, extended the line to Detroit via Wayne and Dearborn, and built offices, shops and power house in Ypsilanti.
1899	The Ypsilanti and Saline Railway completed a line to Saline, and was absorbed by the Detroit, Ypsilanti and Ann Arbor Railway in 1901.
1901	The Detroit, Ypsilanti, Ann Arbor and Jackson Railway absorbed the Detroit Ypsilanti and Ann Arbor Railway and extended the line west from Ann Arbor to Chelsea, Grass Lake and Jackson.
1901	The Detroit and Chicago Traction Co.(the Boland line), was incorporated by W. A. Boland and absorbed the Jackson & Suburban Railway. A line to Wolf Lake and Grass Lake was built from Jackson, track was laid to Chelsea, and the line was graded to Dexter and Ann Arbor.
1905	The Michigan, Ohio and Indiana Railroad incorporated. It constructed a railroad and set poles for electric operation from Toledo, Ohio, to Petersburg, Michigan. Right-of-way was graded to Dundee, Milan and one-half mile south of Ann Arbor.
1907	The Detroit United Railway absorbed the Detroit, Ypsilanti, Ann Arbor and Jackson Railway and operated it as the Detroit, Jackson & Chicago Railway.
1907	The Boland franchises (Detroit & Chicago Traction Company and Jackson, Ann Arbor and Detroit Railway)were purchased by the Detroit, Jackson and Chicago Railway (Detroit United Railway).
1911	The Toledo, Ann Arbor and Jackson Railway acquired the property of the Toledo, Ann Arbor and Detroit Railway (ex-Michigan, Ohio and Indiana Railroad) and operated steam-engine hauled trains between Petersburg and Toledo 1913-1915.
1915	The Toledo-Detroit Railroad absorbed the Toledo, Ann Arbor and Jackson Railway and completed the line to Dundee. It was leased to the Detroit, Toledo & Ironton Railroad and operated as a branch until abandoned in 1965.
1915	The University of Michigan constructed a private electric railway to connect the new power house on the corner of Huron Street and Forest Avenue (now Washtenaw) and the Building and Grounds Building on North University Avenue with the Michigan Central Railroad line. The Michigan Central Railroad was controlled by the New York Central Railroad, and became successively the Penn Central Railroad and the Norfolk Southern Railroad.
1925	Ann Arbor local street cars were replaced with busses.
1925	The Ypsilanti-Saline branch was abandoned.
1928	The bankrupt Detroit, Jackson and Chicago Railway operations were taken over by the Michigan Electric Railway.
1929	End of passenger service and, September 16, end of freight service on Detroit, Jackson and Chicago Railway.
1949	End of electric operation of the University of Michigan railroad.
1969	The University of Michigan railroad was abandoned.
1975	The Ann Arbor Street Railway & Museum imported a 1902 trolley from Lisbon, Portugal, to be operated as a shuttle along Liberty Street from State Street to Main Street.
1979	The 1902 Lisbon trolley was sold to the City of Detroit to operate from Washington Park to the Renaissance center.

For reference, this is a time line for the trolleys illustrated in this book.

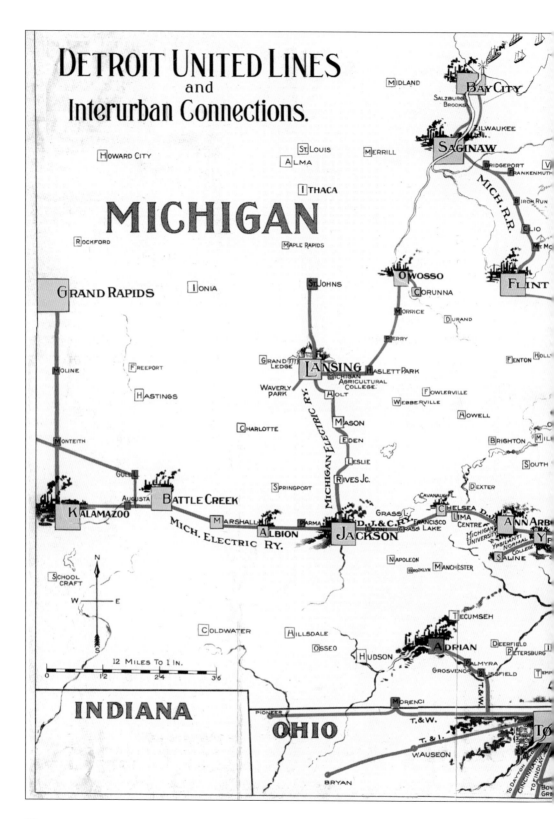

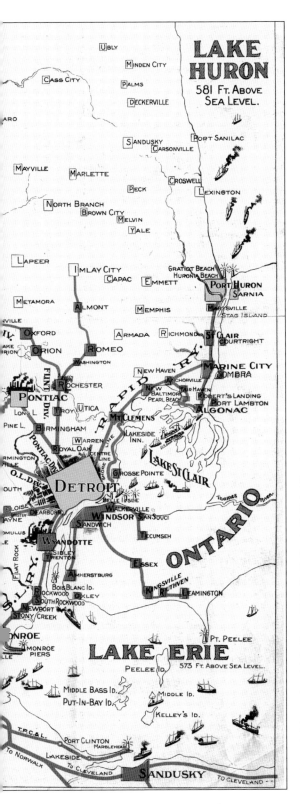

This 1915 Detroit United Railway map shows its entire system of interurban lines. The Detroit United Railway was incorporated in 1900 to take over several streetcar lines in Detroit. Within seven years, all the interurban lines out of Detroit and Windsor, Ontario, were operated by the Detroit United Railway. It also operated streetcars in Ann Arbor, Pontiac, Flint, and Port Huron. The City of Detroit first built competing streetcar lines and finally in 1922 took over all the Detroit local lines, operating them as the Detroit Department of Street Railways. The Detroit United Railway tried to meet bus competition on its interurban lines by acquiring intercity bus lines but went bankrupt in 1925. In 1929, the remaining interurban lines to Flint, Pontiac, and Toledo were reorganized as the Eastern Michigan Railways and the Eastern Michigan-Toledo Railroad, respectively. They lasted until 1931. Detroit streetcars operated until 1956.

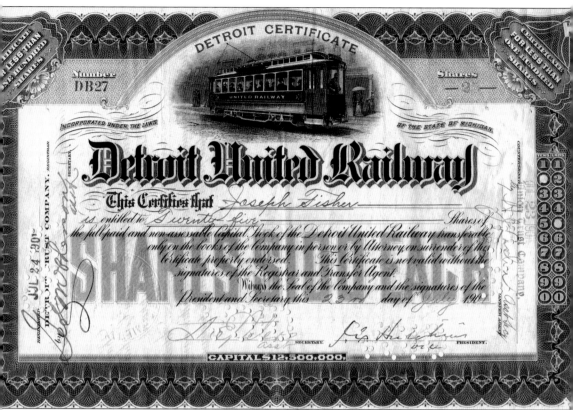

The Detroit United Railway, incorporated in 1901, consolidated all the local streetcar and intercity interurban lines in southeastern Michigan by 1907. This formed the largest interurban network in the country at that time. The network stretched from Detroit to Toledo, Port Huron, Flint, Pontiac, and Jackson. The Detroit, Ypsilanti, Ann Arbor and Jackson Railway operated interurban lines from Detroit to Jackson with branches from Wayne to Plymouth and Northville, and from Ypsilanti to Saline. It was absorbed into the Detroit United Railway conglomerate in 1907. This certificate is signed by Jere G. Hutchins, company president and chairman of the board of directors.

One

YPSILANTI, WHERE IT ALL BEGAN

Ypsilanti was the center of interurban operations in Washtenaw County. Ypsilanti was named after Demetrius Ypsilanti, a Russian officer who fought the Turks for Greek independence in 1822. Ypsilanti was settled in 1823 along the Huron River. The Michigan Central Railroad was built through Ypsilanti and across lower Michigan. Ypsilanti developed a certain amount of manufacturing industry, including a paper mill, an underwear mill, and the McCoy plant to manufacture automatic lubricating systems for locomotives, "the real McCoy." The Michigan State Normal College for teachers was established in 1849 and continues as Eastern Michigan University. Ann Arbor and Ypsilanti were connected in 1892 by the Ann Arbor and Ypsilanti Street Railway, a side-of-the-road steam-dummy railway line. It was electrified in 1896 and the line was extended to Detroit to the east in 1898 and Jackson to the west in 1901. The main offices, repair shop, carbarn, and principal power plant were built in Ypsilanti. Ypsilanti was the eastern end for a 10-mile interurban branch to Saline served by a shuttle car, affectionately called *Old Maud*. The shuttle connected with interurban cars running between Detroit and Ann Arbor and Jackson. The main east–west street in Ypsilanti was called Congress Street but later was renamed Michigan Avenue. Michigan Avenue was part of the Detroit-to-Chicago main highway originally designated as U.S. 112, now U.S. 12.

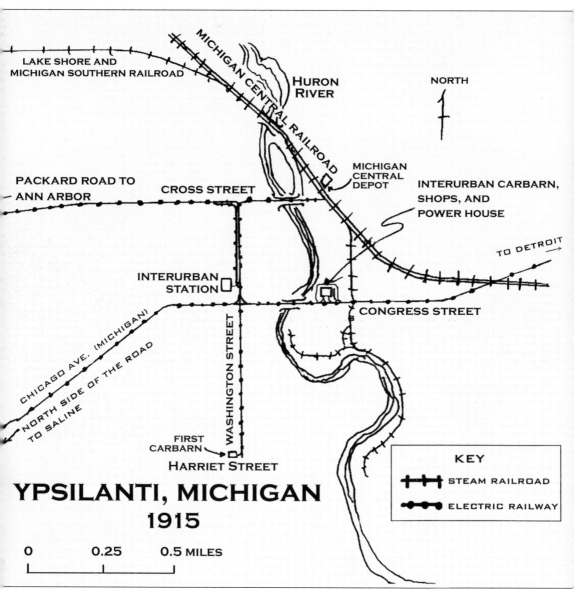

YPSILANTI, MICHIGAN
1915

LAKE SHORE AND
MICHIGAN SOUTHERN RAILROAD

MICHIGAN CENTRAL RAILROAD

HURON
RIVER

NORTH

MICHIGAN
CENTRAL
DEPOT

INTERURBAN CARBARN,
SHOPS, AND
POWER HOUSE

PACKARD ROAD TO
ANN ARBOR

CROSS STREET

TO DETROIT

INTERURBAN
STATION

CONGRESS STREET

CHICAGO AVE. (MICHIGAN)
NORTH SIDE OF THE ROAD
TO SALINE

WASHINGTON STREET

FIRST
CARBARN

HARRIET STREET

KEY

STEAM RAILROAD

ELECTRIC RAILWAY

0 0.25 0.5 MILES

The interurban through town entered from the east on Congress Street, passed the interurban station on Washington Street, and turned west on Cross Street past the Michigan State Normal College to follow Packard Road to Ann Arbor. The branch to Saline followed Chicago Street to Saline. The local streetcar line went from Harriet Street, up Washington Street, east on Cross Street, to the Michigan Central Railroad depot.

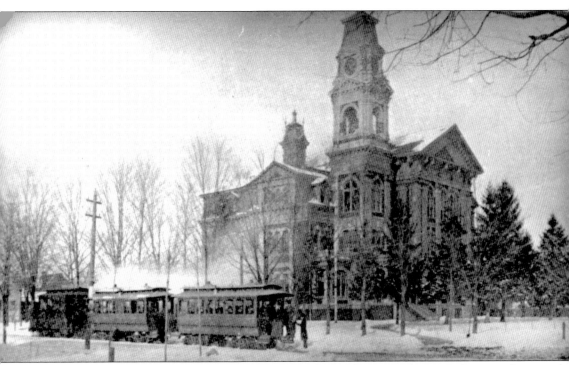

The Ann Arbor and Ypsilanti Street Railway steam-dummy line started running between Ann Arbor and Ypsilanti in 1891. A train is shown puffing past Ypsilanti High School on Cross Street in about 1893. The dark red steam-dummy engine pulling the yellow cars is encased in a passenger car body to make it look like just another streetcar or omnibus. The sight of an open huffing, chuffing engine with whirring pistons coming down the street without the covering car body would have upset horses. Horses that bolted would upset the wagon and riders. This train traveled along the south side of Packard Road to Ann Arbor. It took only 30 minutes to arrive at the courthouse in downtown Ann Arbor. (Ypsilanti Historical Society.)

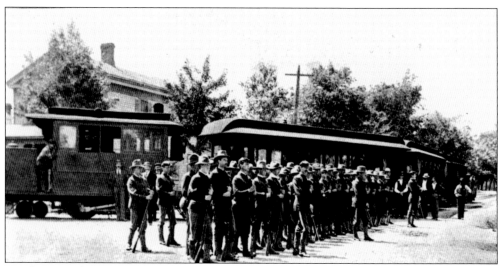

Local National Guard troops line up in front of the Ann Arbor and Ypsilanti Street Railway train sometime before 1896 on the corner of Washington Street and Cross Street. They wear the standard U.S. Army uniform of the 1885 style. The fireman for the steam engine stands in the doorway and watches while the engineer looks out the window. Note the smokestack in the front of the engine. (Lewis White Collection, Ypsilanti Historical Society.)

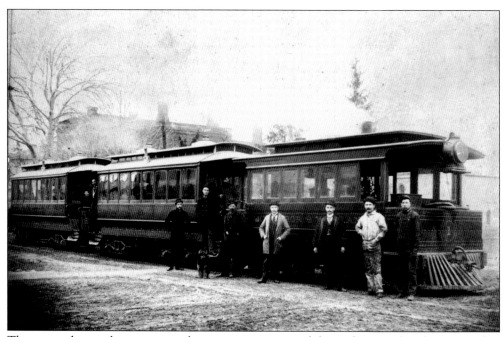

The steam-dummy locomotive and two-car train stopped for a photograph. The cowcatcher and oil headlight are on the front of the engine. The engineer stands in front on the right, and the fireman is next to him. The next two men may be investors such as Junius Beal (with the moustache) and Henry Glover or Daniel Quirk. The fellow on the steps of the first passenger car with brass buttons on his coat is the conductor. (Ypsilanti Historical Society.)

Ann Arbor and Ypsilanti Street Ry.

═══TIME TABLE.═══

TAKING EFFECT SUNDAY, NOV. 19, 1893.

LEAVE YPSILANTI.		LEAVE ANN ARBOR
From Harriet St.	*From Congress St.*	*From Court House*
7:11 a. m.	7:15 a. m.	7:25 a. m.
8:56	9:00	9:10
10:56	11:00	11:10
12:41 p. m.	12:45 p. m.	12:55 p. m.
2:26	2:30	2:40
4:26	4:30	4:40
6:26	6:30	6:40
8:56	9:00	9:10
10:26	10:30	10:40

SUNDAY TIME.

1:26 p. m.	1:30 p. m.	1:40 p. m.
3:26	3:30	3:40
5:26	5:30	5:40
7:26	7:30	7:40
9:26	9:30	9:40

Nights of entertainments the last train will be held to accomodate those wishing to attend if conductor is notified.

CARS RUN ON CITY TIME.

Coupon Tickets 15 cents. For sale by Conductors.

This 1893 timetable shows that the steam-dummy trains operated every two hours during the day. There is obvious confusion about departure times. If the train leaves Congress Street in Ypsilanti at 7:15 a.m. and also leaves Ann Arbor at 7:25 a.m., it would either have to make the trip in less than 10 minutes or another train would have to leave from Ann Arbor. However, the timetable says that "cars run on city time." Before standard time was adopted, Detroit local time was 28 minutes ahead of railroad central time. Ypsilanti was likely using Detroit time, while Ann Arbor was on railroad central time. Michigan was still on central time in 1929 while Detroit was on eastern time, and the interurbans operated by Detroit time.

Ypsilanti was hit by a tornado on April 12, 1893, that swept right through downtown, leaving this horse-drawn streetcar on the corner of Washington Street and Congress Street (Michigan Avenue). The horsecar served the Michigan Central Railroad station in Depot Town, traveled west on Cross Street, then turned south on Washington Street to Harriet Street on the south side of Ypsilanti. The carbarn for the steam-dummy line was located at Harriet Street between Washington and Adams Streets. (Ypsilanti Historical Society.)

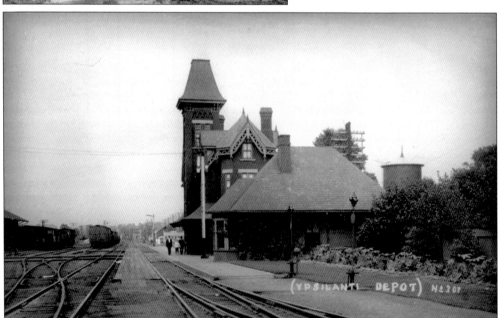

The Michigan Central Railroad depot was at the north end of the horsecar line. After electrification, local streetcars ran from the depot, across the Huron River on Cross Street, and south on Washington Street to Harriet Street. They may have run west on Cross Street to Mansfield, where the interurban tracks moved to the south side of Packard Road. Trains to Hillsdale on the Lake Shore and Michigan Southern Railroad started their run here.

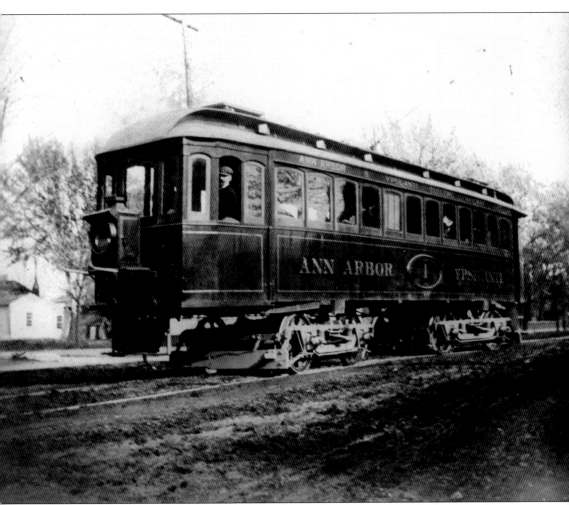

No. 1 was the first electric car operated by the newly electrified and renamed Ann Arbor and Ypsilanti Electric Railway. It is turning from Washington Street onto Cross Street in Ypsilanti in 1896. This car had been hastily converted from a passenger car trailer of the steam-dummy line into an electric trolley car by lengthening it and replacing its two four-wheeled trucks with a pair of motorized trucks. Each axle was driven by a 50-horsepower motor. The open platform in front has been enclosed and the oil headlight from the dummy engine mounted in front. The car was brightly repainted and a spring-loaded trolley pole mounted on the roof. Voilà, an electric interurban car! (Ypsilanti Historical Society.)

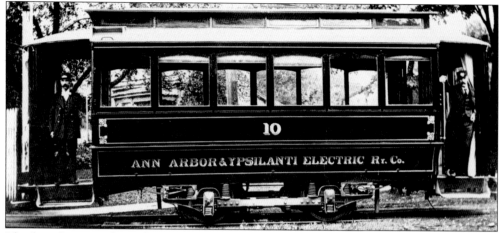

This brand-new single-truck car probably ran on the local streetcar line in Ypsilanti, replacing the horsecar. The local service ran from the Michigan Central Railroad station in Depot Town to the end of the line at Harriet Street. At the end of the line, motorman Norman Ayers (on the right) would remove his key from the controller box and go to the other end of the car and insert his key. Meanwhile, the conductor, Charles Desbrow (on the left), pulled the trolley pole off the wire with the attached rope, walked it around the car, and placed it back on the wire at the other end. This image was given to author H. Mark Hildebrandt by the late Marie Cady.

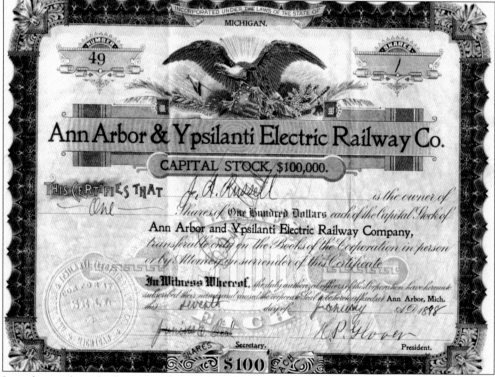

In order to electrify the steam-dummy line from Ann Arbor to Ypsilanti, it was necessary to raise money. The owners went to New York, interested investors in the project, and sold stock to finance the electrification of the line. The interurban craze was on. (Junius Beal File, Bentley Historical Library.)

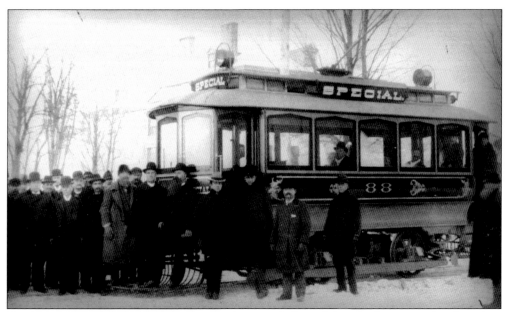

On December 24, 1897, the Detroit, Ypsilanti and Ann Arbor Railway completed its line from Detroit's Addison Street, the end of the Detroit Citizen's Street Railway line, west to Dearborn. The first car, No. 88, was the private car of Antoine B. du Pont, superintendent of the Detroit Citizen's Street Railway. The officials in front also include J. D. Hawks, S. F. Angus, and Jere G. Hutchins, vice president and general manager of the Detroit Citizen's Street Railway and later president and chairman of the board of the Detroit United Railway. (Ypsilanti Historical Society.)

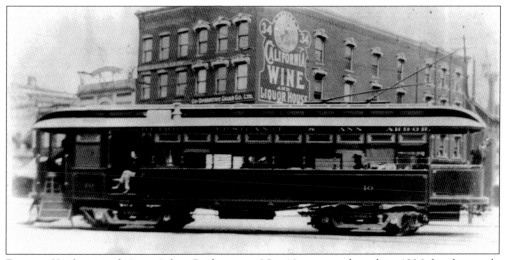

Detroit, Ypsilanti and Ann Arbor Railway car No. 10 was purchased in 1896 for the newly extended line to Detroit. There is a front entrance on the left side and a rear entrance on the right rear. There are two trolley poles. In Detroit, one pole is used to meter the power for the Detroit Citizen's Street Railway, and the other pole is used on the line from Detroit to Ann Arbor. The photograph was taken in Detroit in about 1897. (Burton Historical Collection, Detroit Public Library.)

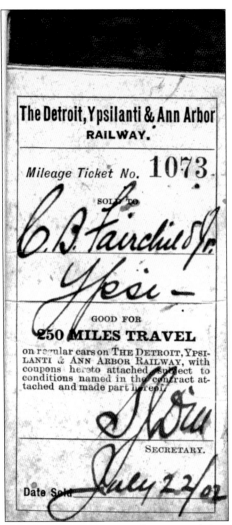

The Detroit, Ypsilanti & Ann Arbor
RAILWAY.

Mileage Ticket No. **1073**

SOLD TO

C. B. Fairchild Jr.

Ypsi —

GOOD FOR

250 MILES TRAVEL

on regular cars on THE DETROIT, YPSI-
LANTI & ANN ARBOR RAILWAY, with
coupons hereto attached subject to
conditions named in the contract at-
tached and made part hereof.

SECRETARY.

Date Sold *July 22/02*

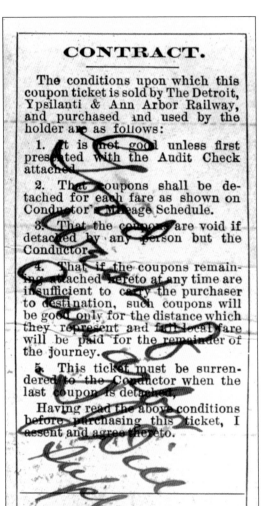

CONTRACT.

The conditions upon which this
coupon ticket is sold by The Detroit,
Ypsilanti & Ann Arbor Railway,
and purchased and used by the
holder are as follows:

1. It is not good unless first
presented with the Audit Check
attached.

2. That coupons shall be de-
tached for each fare as shown on
Conductor's Mileage Schedule.

3. That the coupons are void if
detached by any person but the
Conductor.

4. That if the coupons remain-
ing attached hereto at any time are
insufficient to carry the purchaser
to destination, such coupons will
be good only for the distance which
they represent and full local fare
will be paid for the remainder of
the journey.

5. This ticket must be surren-
dered to the Conductor when the
last coupon is detached.

Having read the above conditions
before purchasing this ticket, I
assent and agree thereto.

Nice handwriting graces the cover of this 250-mile ticket book for the Detroit, Ypsilanti and Ann Arbor Railway. Since the railway extended its line west to Jackson in 1902 and added Jackson to its list of names, the back was signed to validate the tickets for use on the new line west of Ann Arbor.

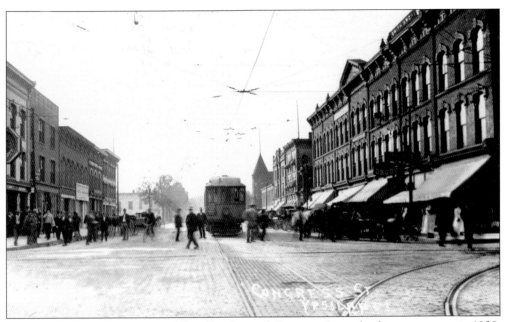

The Saline car stands in the middle of brick-paved Congress Street loading passengers in 1908. The sign on its front reads, "Detroit, Dearborn, Wayne, Ypsilanti, Saline" for the trip to Detroit during a six-month trial of through service from Saline to Detroit. The track curving to the right leads onto Washington Street and the interurban station. The cross track in the foreground is for the local streetcar line south on Washington Street to Harriet Street.

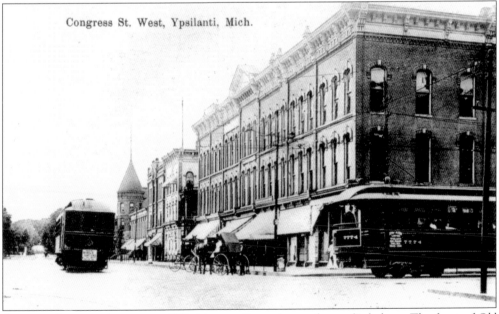

Congress Street at the corner of Washington Street is seen here a little later. The front of *Old Maud*, the shuttle car to Saline on the left, now sports a notice for a Bible conference. The interurban car on the right has just arrived from Detroit. Its sign reads, "Ann Arbor Limited; Ypsilanti, Ann Arbor, Chelsea, Grass Lake." The conductor stands on the open back platform, ready to assist the passengers when the car gets to the station.

23

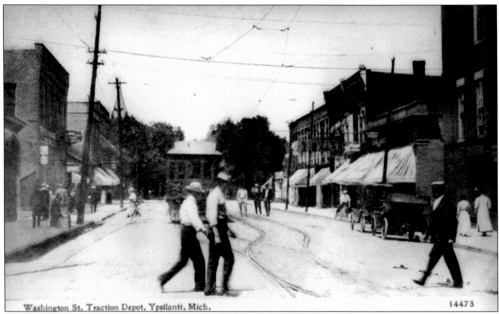

Washington St. Traction Depot, Ypsilanti, Mich. 14473

In this 1912 view looking north on Washington Street, an interurban car headed for Detroit loads in front of the Detroit, Jackson and Chicago Railway station. It has an oval sign reading "Detroit United Lines, Waiting Room and Ticket Office." In the foreground is the switch for tracks to turn onto Congress Street and just beyond it is the switch for a stretch of double track that extends around the corner of Cross Street.

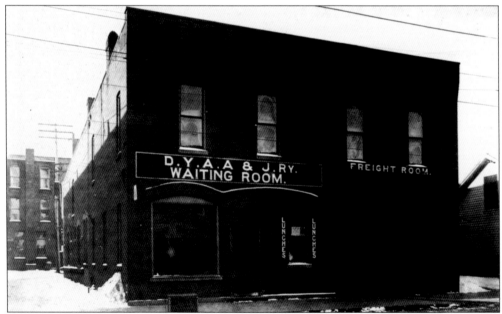

When the Detroit, Ypsilanti, and Ann Arbor Railway interurban line completed the line to Jackson, *Jackson* was added to its corporate name. This Ypsilanti interurban station building housed the waiting room, a lunch counter, and a freight room. A branch of the track from the street in front of the station curved into the freight room so that an express car could be loaded and unloaded inside the station. Express was handled by the United States Express Company.

THE DETROIT, YPSILANTI & ANN ARBOR RAILWAY

GOOD FOR THIS DAY AND TRAIN ONLY. Passenger's receipt for mileage paid for one continuous ride between Detroit and Mile Post punched.

Mile Post

0	18
1	19
2	20
3	21
4	22
5	23
6	24
7	25
8	26
9	27
10	28
11	29
12	30
13	31
14	32
15	33
16	34
17	35

1 2 3 4 5 6 7 8 9 10 11 12 13 14 15 16 17 18 19 20 21 22 23 24 25 26 27 28 29 30 31

Amnt. in miles

5	21	37
	22	38
7	23	39
8	24	
9	25	
10	26	
11	27	
12	28	
13	29	
14	30	
15	31	
16	32	
17	33	
18	34	
19	35	
20	36	

MONTHS
1 2 3 4 5 6 7 8 9 10 11 12

Form Thro. Mileage

121753

SECRETARY.

This fare receipt was issued sometime between 1898 and 1901 for a trip on the Detroit, Ypsilanti and Ann Arbor Railway. Punch marks indicate the date, July 22, since 7 in the right-hand field is punched, and for the day the 22 in the lower left corner is punched. It also shows that the trip was between mileposts 25 (Ypsilanti) and 31 (Wells Street in Ann Arbor), six miles. The fare is not shown but was about 15¢. The shape of the punch, a horse, identifies the conductor, since each conductor had his own punch pattern. That way the auditor could identify the person responsible for collecting the fare.

In 1907, East Congress Street stretches down the hill from Prospect Street to the bridge across the Huron River. The interurban line runs down the middle of the dirt street while the buggies and automobiles use the sides of the street. The boards between the rails on the right indicate where Prospect Street crosses Congress Street. The crossbars on the telephone posts carry telephone lines above, interurban telephone lines in the middle, and the interurban power feeder line below.

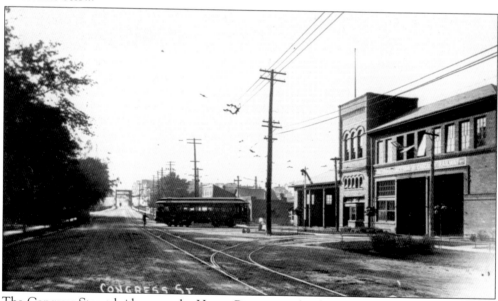

The Congress Street bridge over the Huron River is in the distance. An interurban car turns into the carbarn. The conductor has removed the lanterns from the rear of the car to place them on the ground at the foot of the telephone pole. The train order signal is in the down position to indicate no train orders from the dispatcher. Across the shop bay to the right is the new name of the interurban line, Detroit, Jackson and Chicago Railway, indicating that the photograph was taken after 1907.

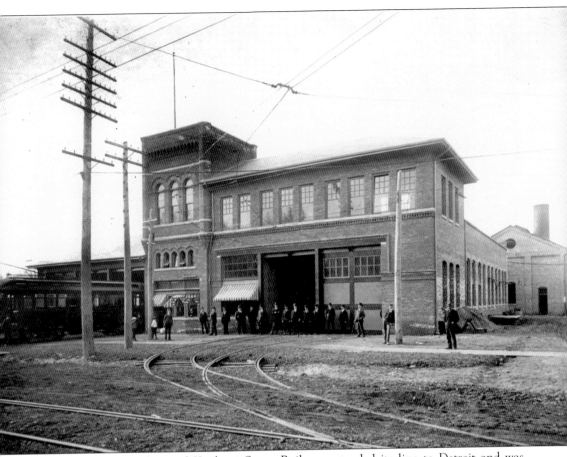

In 1898, the Ann Arbor and Ypsilanti Street Railway extended its line to Detroit and was renamed the Detroit, Ypsilanti and Ann Arbor Railway. The carbarn, shop, and power plant complex was built in 1897 on Congress Street in Ypsilanti just east of the bridge over the Huron River. The left bay, containing three tracks, is the carbarn. The right bay, containing two tracks, is enclosed and used for a repair shop. The center part is the dispatcher's office and the second floor is for company offices. In the rear, the power plant is being completed, with a brick stack partly built. The power plant will contain three coal-fired boilers that will serve generators to produce 600-volt direct current (DC) power for the line. Fourteen well-dressed gentlemen, probably investors, are arrayed in front of the shop doors plus a young courier carrying a package and two young fellows leaning on telephone poles. The superintendent watches the scene from the window. (Ypsilanti Historical Society.)

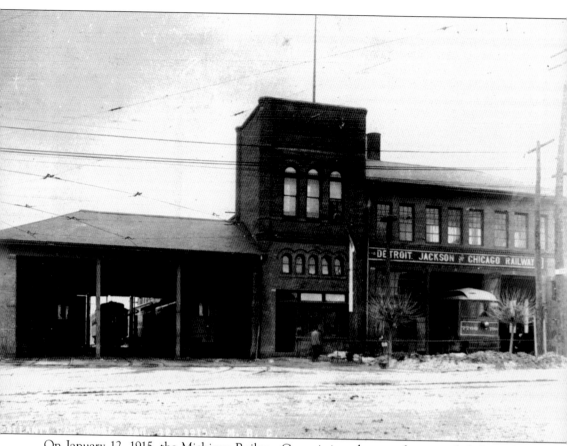

On January 12, 1915, the Michigan Railway Commission photographer recorded the carbarn and shops building on Congress Street (Michigan Avenue). There are several interurban cars in the carbarn on the left and Detroit, Jackson and Chicago No. 7766 in the shop bay on the right. The railroad commission required an audit of all the railways in the state at that time, including the streetcar and interurban companies.

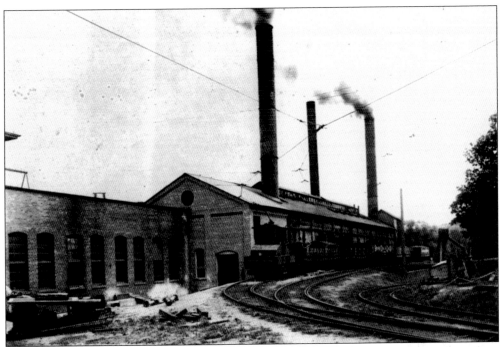

On the east side of the new power plant, an electric switch engine moves wooden coal cars from the Kanawha and Michigan and the Toledo and Ohio Central Railways into position. Workers will drop the sides of the cars to unload the coal directly into the coal coffers so that the firemen can stoke the boilers.

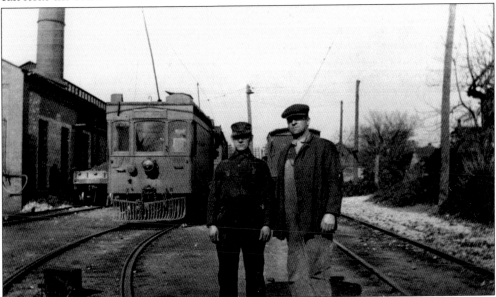

These shop workers stand in front of interurban work car No. 7288 on the east side of the old power plant before 1902. The work car has a link and pin coupler and a chain for hauling. To the left of the headlight is the trolley rope retriever, a spring-loaded reel for holding the trolley pole rope. The trolley pole was hooked down under the hook in the middle of the roof when the work car was operated forward. (Donald Moore collection.)

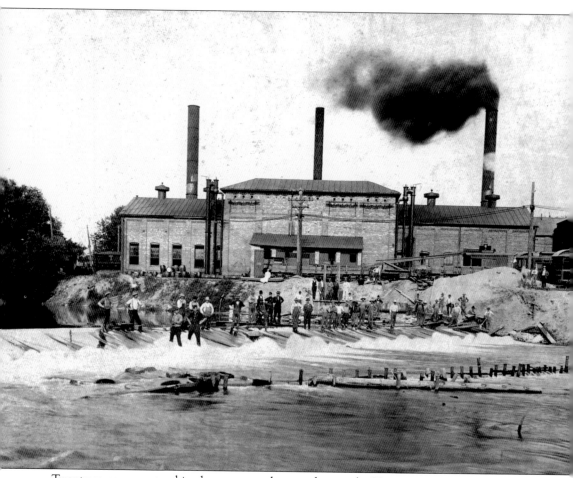

Twenty-seven men stand in the water on the new dam in the Huron River, thirteen are on the bank, and a lady in a white dress sits on the bank, watching. The dam was built in 1902 to provide a steady source of water for the boilers. The men are probably the boilermakers, pipe fitters, and electricians installing the new boilers, steam engines, and generators in the new building. The smoking stack on the right serves the original power plant built in 1898 when the interurban was extended to Detroit. In this 1902 photograph, the new power plant with its two smokestacks has not been put into service yet. It will provide power for the Saline branch and the extension of the interurban line to Jackson. The interurban cars on the right are behind the carbarn. There is a steam crane in back of the interurban cars on the right. A loaded wooden coal car from the Toledo and Ohio Central Railway can be seen on the track on the other side of the powerhouse. The photograph is attributed to Charles Cooper. (Ypsilanti Historical Society.)

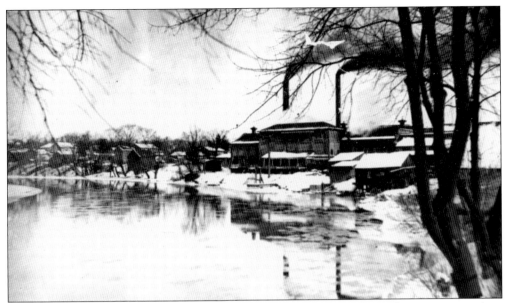

This photograph from the Congress Street Huron River bridge shows the new power plant addition built in 1902 directly behind the original powerhouse. It generated 22,500-volt alternating current (AC) to send out on the power cables hung from the telephone poles along the interurban line. The current will be reduced to 600-volt DC at the substations built every 15 miles. The boilers provided steam to operate the steam engines that ran the eight generators that produced the electricity. (Ypsilanti Historical Society.)

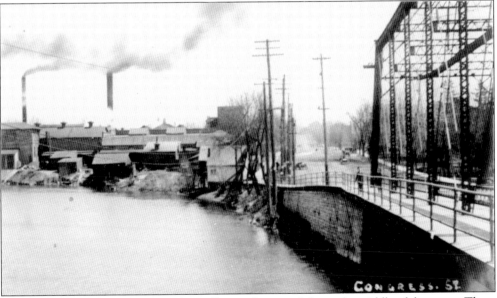

Looking east on Congress Street, the trolley tracks extend down the middle of the street. There is a board above the trolley wire on the bridge to protect the bridge if the trolley should come off the wire. The interurban shops complex with its smoking stacks indicates that the boilers are fired up. This photograph was taken before 1915, since in 1915 electric power was purchased from Detroit Edison and this power plant was taken out of service. (Lewis White Collection, Ypsilanti Historical Society.)

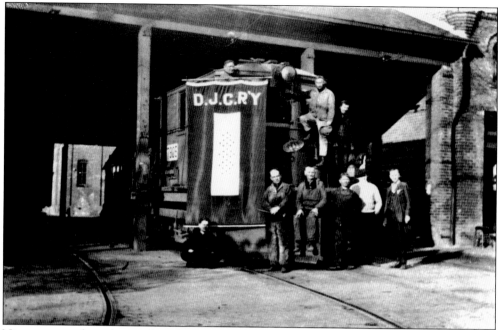

Nine men are draped around work car No. 7805 in the middle bay of the interurban carbarn. They are proud of the banner awarded to the Detroit, Jackson and Chicago Railway shops. It has 30 stars in the middle field. It is not clear if this award is for purchasing war bonds or for safety. The work car has a lamp on its front to illuminate track work being done at night and a snowplow in front.

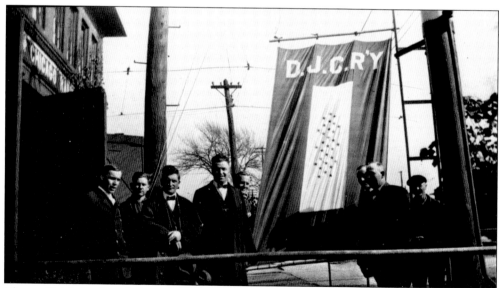

These officials in their dark suits and bow ties are celebrating whatever this banner represents, with its 30 stars in the center field. The initials on the flag are for the Detroit, Jackson and Chicago Railway, and the ceremony is in front of the shop building on Congress Street. Perhaps it is for war bond purchases or a safety record, although the railway did have its share of accidents, some of which are illustrated in chapter 7.

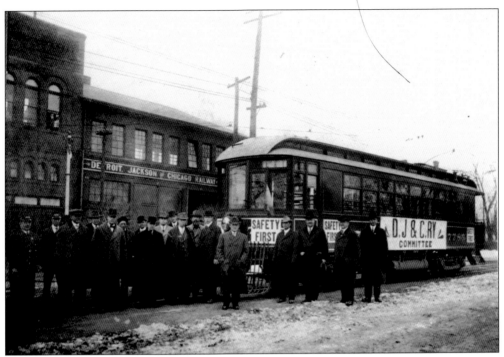

The Detroit, Jackson and Chicago Railway Safety Committee has arrived at the shops in car No. 7785. The committee consists of 16 gentlemen in coats with velvet lapel coats, wearing black homburgs. On the far left is the interurban conductor in his double-breasted coat. The brass buttons are embossed with "DJ&C Ry." Maybe this visit followed the disastrous wreck in Chelsea in July 1918 that caused 14 deaths and the safety committee wanted to tune up the employees to be more careful.

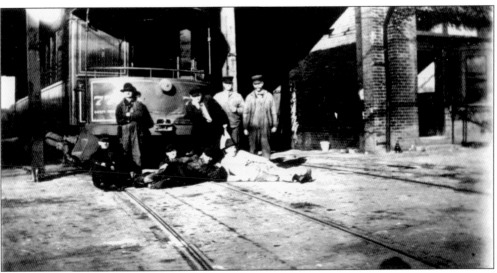

On an afternoon break on a bright spring day, some of the shop workers are spread out around the back of interurban car No. 7794. They are on the center track of the carbarn section of the carbarn and shop building on Congress Street. It was hard work keeping those machines in good, safe running condition and a few minutes off were welcome to have a little fun!

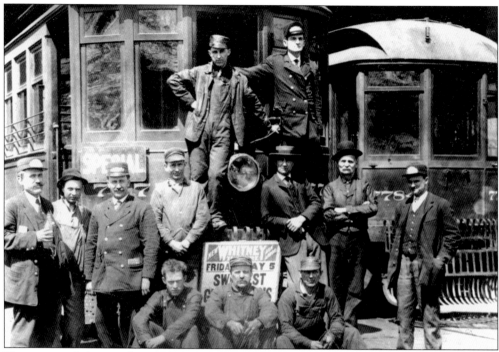

Trainmen and shop workers pose in front of interurban car No. 7777 in May 1911. The poster on the front of the car advertised *The Sweetest Girl in Paris*, a musical that was coming to the Whitney Theater in Ann Arbor on May 5, 1911. The men with the brass buttons and cap badges are motormen or conductors. The fellow standing third from the right with the straw boater may be an office worker.

New Whitney Theater

FRIDAY, MAY 5

Absolutely the Best and Largest Musical Comedy Company That Has Ever Appeared in Ann Arbor. Everywhere, Everybody's Just Raving About

THE SWEETEST GIRL

IN PARIS

Trixie Friganza, Alex. Carr, Fred V. Bowers, Dorothy Brenner, Catherine Rowe Palmer, Zoe Barnett.

17 SONGS, 48 GIRLS.

Identical cast and chorus seen 261 nights at the La Salle Opera House, Chicago.—The long run record of the season.

Prices--50c, 75c, $1, $1.50, $2

SEAT SALE WEDNESDAY, MAY 3RD.

On Wednesday, May 3, 1911, the *Ann Arbor Times News* ran this advertisement for *The Sweetest Girl in Paris*. The Whitney Theater was on Main Street opposite the courthouse in Ann Arbor. The interurban made it easy for out-of-town theatergoers to attend stage shows, concerts, and football games in Ann Arbor. (Ann Arbor District Library microfilm files.)

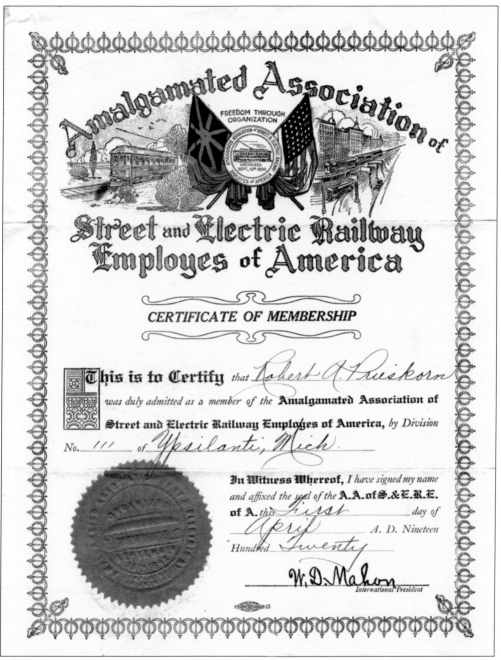

Robert Prieskorn became a member of the Amalgamated Association of Street and Electric Railway Employees of America, Division 111, on April 1, 1920, in Ypsilanti. The union dates back to 1892 and covered employees of streetcar, interurban, subway, and elevated lines. The union still exists as the Amalgamated Transit Union (ATU), the largest transit union in the country. (Ypsilanti Historical Society.)

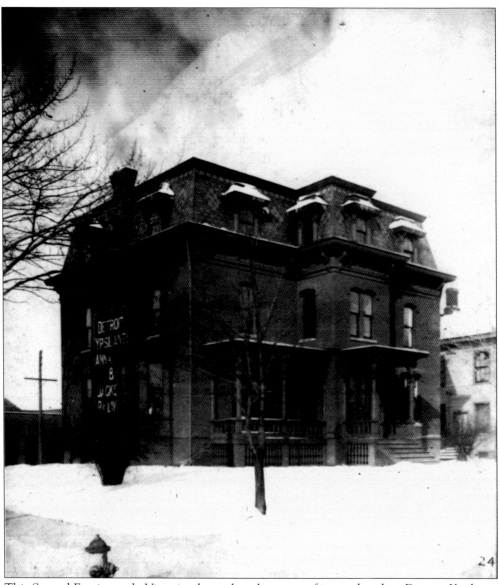

This Second Empire–style Victorian house has the name of interurban line Detroit, Ypsilanti, Ann Arbor and Jackson Railway painted on its side. Located on the corner of River Street and Congress Street, it served as the railway office headquarters. The interurban powerhouse and shops stood directly west and can be seen in the background. In 1907, the Detroit United Railway photographer took this photograph when the interurban property was purchased by the Detroit United Railway and renamed the Detroit, Jackson and Chicago Railway. (Ypsilanti Historical Society.)

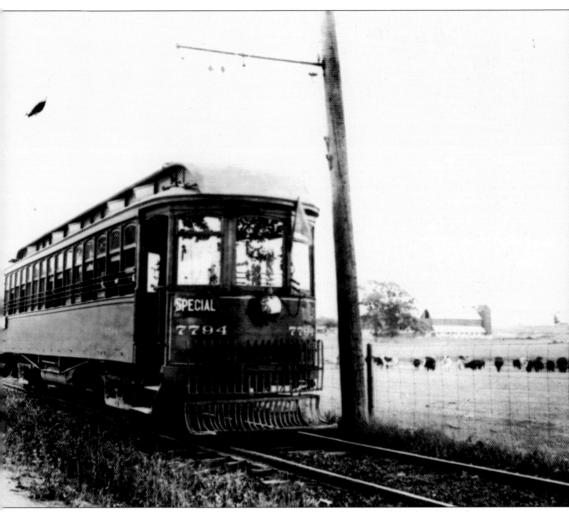

The photographer's special car, No. 7794, stops at Golfside Road and Packard Road to capture this bucolic scene of grazing cows. This is the location of the present Washtenaw Country Club. The Cole Brothers dairy barn is visible across the creek, which still runs through the Washtenaw Country Club golf course. The interurban car displays a white flag to indicate that it is an extra, or nonscheduled, car. The company photographer roamed the system taking scenic photographs to advertise the countryside and interest customers in riding the trolley for pleasure. The interurban tracks were on the south side of Packard Road.

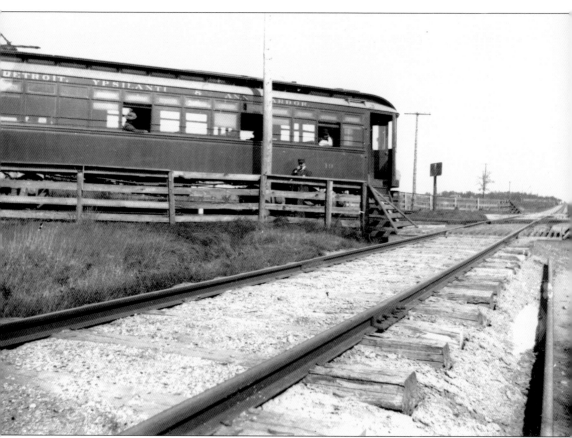

Interurban car No. 19 of the Detroit, Ypsilanti and Ann Arbor Railway has stopped on Packard Road at the crossing of the Lake Shore and Michigan Southern Railroad branch, which connected Ypsilanti with Hillsdale, known as the Huckleberry Line. The conductor is talking to the dispatcher on the company telephone line to get clearance to cross the railroad tracks. The steam railroad branch crossed Packard Road and the interurban line just west of Golfside Road. It was built as the Detroit, Hillsdale and Indiana Rail Road in 1871 and leased to the Lake Shore and Michigan Southern Railroad in 1881. Its right-of-way can be seen today because it is now a power line right-of-way. (Ypsilanti Historical Society.)

Two

Ann Arbor Expansion

The University of Michigan moved from Detroit to Ann Arbor in 1837. By 1890, it was the largest university west of the Appalachian Mountains with about 3,000 students. Walking, bicycling, and horse and buggy or horse-drawn cabs were adequate transportation for a small town. With the large number of students, local investors built a local streetcar line in 1890 to connect the railway station with the downtown commercial area and the university campus. Other local investors built a local railway in 1892 connecting Ann Arbor with Ypsilanti, just seven miles east. Ypsilanti was the site of the Michigan State Normal College for teachers, later Eastern Michigan University. Some of these investors had experience traveling and were familiar with local suburban railways in Europe that were operated with a steam dummy—a small steam engine encased in a passenger car body—that pulled one or two cars. The success of the Ann Arbor and Ypsilanti Street Railway steam-dummy line led to electrification in 1896 and extension to Detroit in 1898. By this time, the interurban craze was upon the country, and major investment in local electric interurban lines was popular. In 1902, the interurban line was extended west to Jackson. It was taken over by the Detroit United Railway in 1907 and renamed the Detroit, Jackson and Chicago Railway. Streetcar service in Ann Arbor lasted until January 1925 and the interurban ran until September 1929.

More recently, a heritage trolley was proposed along Liberty Street to connect the State Street business area and Main Street. In 1978, the Ann Arbor Trolley and Museum imported a historic 1907 Brill trolley made in the United States from Lisbon, Portugal. The trolley was stored while the owners negotiated with the city and the Ann Arbor Transit Authority to get the line built and operating. Due to lack of funding, the project died. Detroit bought Ann Arbor's trolley and ran it on the short-lived vintage trolley line from Washington Park to the Renaissance Center.

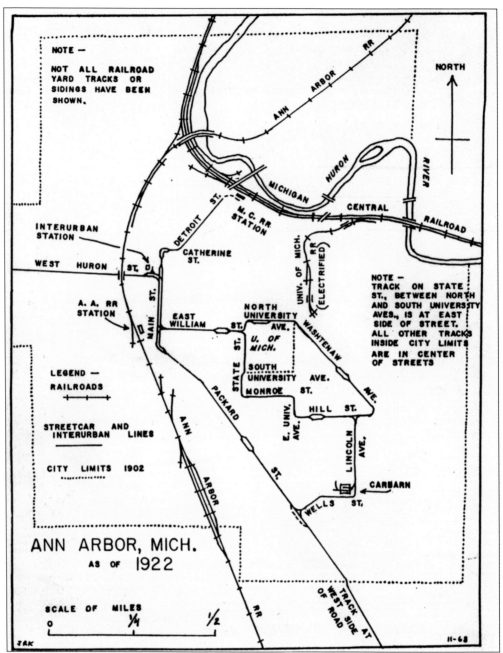

The streetcar and interurban lines are shown on this map with plain lines. The steam railroads are crosshatched. The original streetcar system extended from the Michigan Central Railroad station to the University of Michigan, looping back via Lincoln Avenue, Wells Street, and Packard Road. In 1894, the campus loop via Monroe Street was closed. The steam-dummy line to Ypsilanti operated along Packard Road and connected with local streetcars at Wells Street until it was electrified. The interurban to Jackson went out West Huron Street. In 1912, local cars ran on West Huron Street to Glendale Switch at the top of the hill. The University of Michigan electrified railroad is shown.

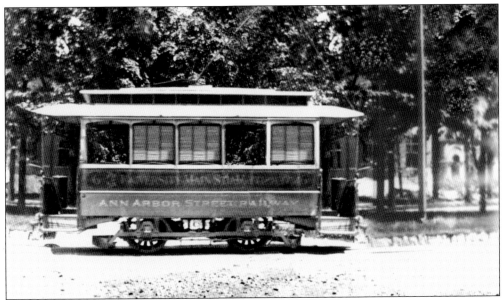

On a bright June day in 1891, the new trolley No. 6 is stopped at the corner of North University Avenue and State Street for a photograph. Ann Arbor's first streetcars ran from the Michigan Central station to Main Street, up William Street to the university, out Washtenaw Avenue to Hill Street, down Lincoln Avenue to Wells Street, and back to Main Street on Packard Road. A carbarn fire destroyed five of the six cars in 1894. (Sam Sturgis Collection, Bentley Historical Library.)

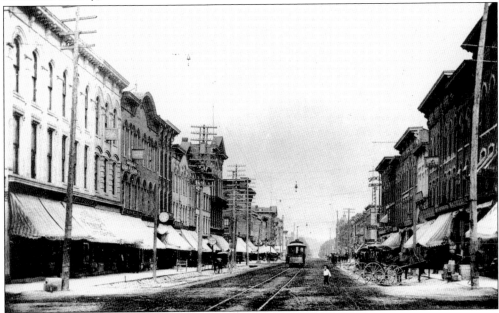

When the trolleys first ran in 1890, Main Street was dirt. This new trolley car is crossing Washington Street, headed for a passing siding at Ann Street. There is a little fellow crossing the street, now that the streetcar has passed. Every store has an awning. The telephone poles have nine crossbars to handle the new telephone lines. Electric lights are strung across the street between the buildings, providing two lights per block. (Bentley Historical Library HS3688.)

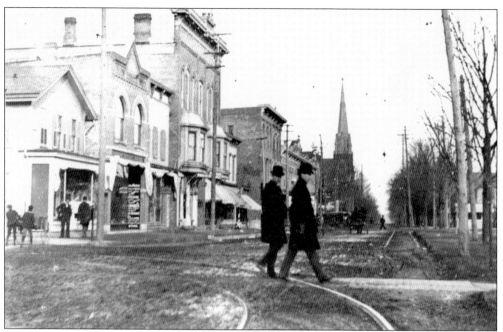

Two fellows are walking across a muddy State Street at the corner of William Street on the brick sidewalk crossing. The car tracks, which turned from North University Avenue onto State Street, can be seen along the curb on the right. After the carbarn fire of January 1894, the streetcars did not run until the new cars arrived in September 1894. This photograph must have been taken in the spring of 1894. (Bentley Historical Library HS1634.)

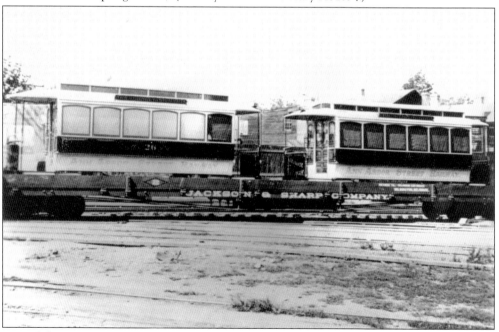

Two of the six new cars are on their way to Ann Arbor in 1894 from the Jackson and Sharp Car Company in Dayton, Ohio. They were put on their four-wheeled trucks in Ann Arbor and resumed the local streetcar service.

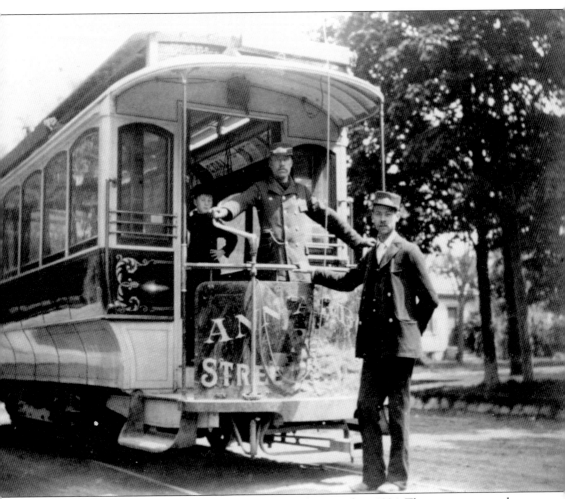

One of the new streetcars, No. 26, has stopped for its photograph in 1894. The motorman on the open front platform has one hand on the hand-brake lever and the other hand on the controller. Winding the brake lever will tighten the brake chain and draw the brake shoes against the wheels. The conductor, standing in front of the car, helps the passengers on and off the car at the back platform and collects 5¢ fares or single-ride tickets, which cost six for a quarter. The passenger inside waits for the photographer to finish so he can get to his train. Car-card advertising lines the ceiling below the clerestory windows. The cars ran every 15 minutes during the day. At eight miles an hour, they were much faster than a horse-drawn buggy. (Bentley Historical Library.)

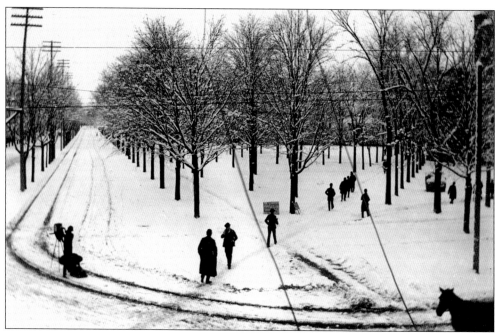

The streetcar has traced the car tracks in the snow on North University Avenue in about 1893. A wagon has passed along the right side of the tracks. A photographer has a view camera on a tripod in the middle of the car tracks. Students walk along the old diagonal walk through campus. The law building is just visible on the right. (Bentley Historical Library HS1595.)

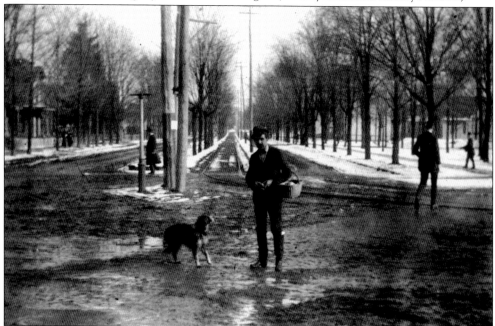

A fellow and his dog stand in the middle of State Street on a snowy spring day in about 1900. The walk across the street is paved, but the street is a sea of mud. The North University Avenue car tracks are now separated from the street by a line of telephone poles. (Bentley Historical Library HS1595.)

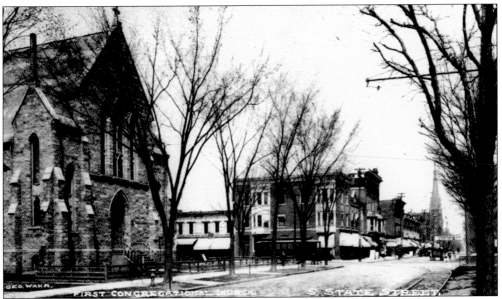

At the corner of William Street and State Street, the trolley has just turned the corner from North University Avenue after circling the campus via Washtenaw Avenue and Hill Street. The track in the foreground is next to the curb on State Street, and the trolley wire bracket hangs from the pole. On the left is the First Congregational Church. The man with a shovel on the right is shoveling horse dung into the wagon. The date is about 1912.

A couple of young men walk up the hill from the Michigan Central Railroad station to State Street around 1898. The Ann Arbor Street Railway trolley is waiting for passengers at the end of the line by the express building. In 1902, one of the trolley's brakes failed on the Carey Street hill and ran off the track. After that, the trolleys stopped at the end of the Broadway Street bridge and the passengers had to walk down the hill. (Burton Historical Collection, Detroit Public Library.)

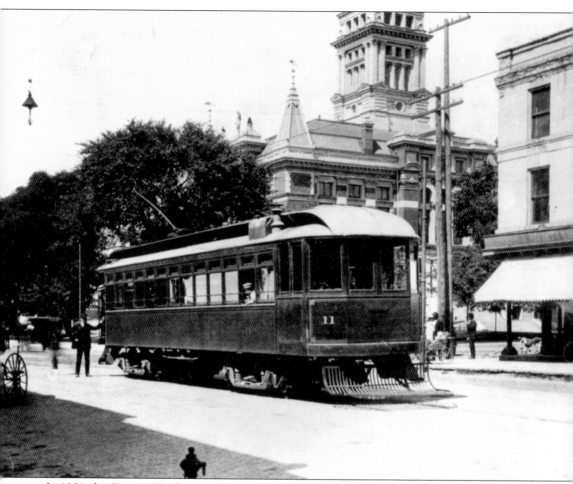

In 1901, this Detroit, Ypsilanti and Ann Arbor Railway interurban car sits at the corner of Main Street and Huron Street, waiting to leave for Detroit. The conductor is standing by the back steps to help the passengers board. In the background are the spires and tower of the Washtenaw County Court House surrounded by trees. The street has been paved with brick paving blocks, a substantial improvement over the previous dirt surface. This photograph is from the White Photo Studio.

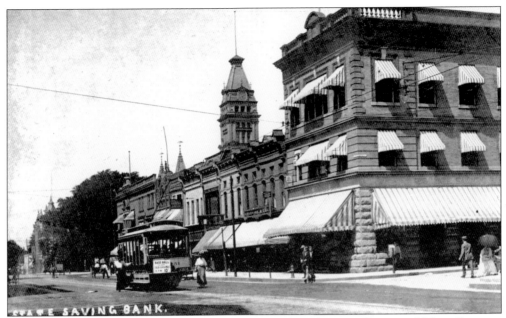

An open trolley has stopped to load at the corner of Washington Street and Main Street in about 1908. The poster on the end of the car announces "Baseball Today, Fair Grounds, 2.P.M. 10¢." The fairgrounds were across from the carbarn where Burns Park is now. The North sign on the other side of the back indicates that the trolley circled the campus on the north or North University Avenue side of the campus loop.

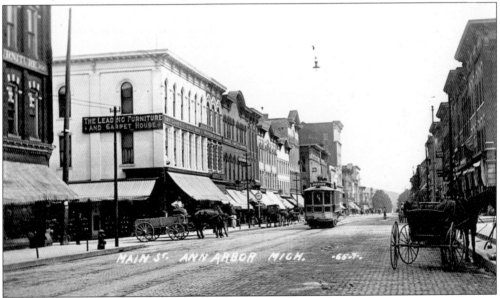

A local trolley glides north on Main Street headed for the Michigan Central Railroad depot. The horse-drawn wagon on the left has waited for it to cross Liberty Street. The Mack and Company furniture store is on the corner behind the wagon. Down the street is the new seven-story Glazier Building erected in 1908. When the Detroit United Railway took over the local streetcar system in 1907, closed-platform streetcars were introduced and continued to operate until the end of service in 1929. (Bentley Historical Library HS1581.)

Take a stroll along muddy Washtenaw Avenue in the fall around 1912. This photograph shows a couple of ghostlike college students strolling down the concrete sidewalk on the right. Every 15 minutes the local trolley rolls by in the middle of this street on its way to campus. Next to the sidewalk on the left is one of the brick pillars erected by the Phi Kappa Psi fraternity, which moved into the Chauncey Millen house on the corner of Washtenaw Avenue and Hill Street. (Bentley Historical Library.)

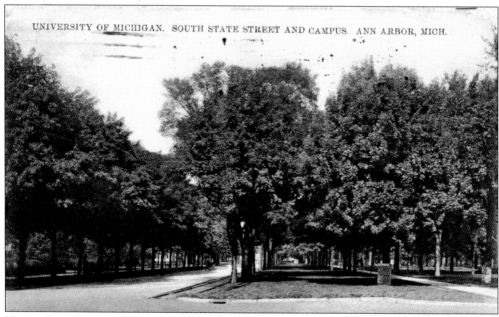

Here is State Street and the corner of South University Avenue in about 1912. A horse and buggy clops up State Street. The trolley tracks run alongside State Street in front of the university campus. The double row of trees blocks the view of the University of Michigan Museum Building (later the Romance Languages Building) and University Hall on the right. A row of handsome houses and Newberry Hall on the left side of the street are obscured by the trees.

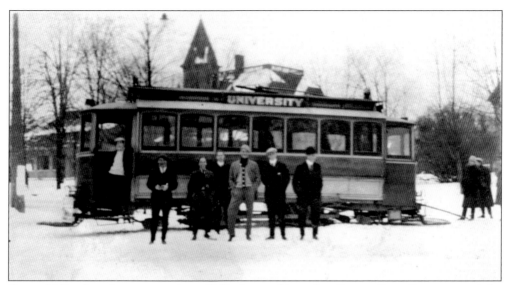

One cold Sunday afternoon in about 1912, the southbound trolley on State Street jumped the tracks onto South University Avenue. A switching pole is attached to the right end to pull it back on the tracks. Several students from the nearby fraternities came out to get their photograph taken. In back of the trolley is the Alpha Delta Phi house on the left, and the old Sigma Chi house is behind the trolley. (Psi Upsilon File, Bentley Historical Library.)

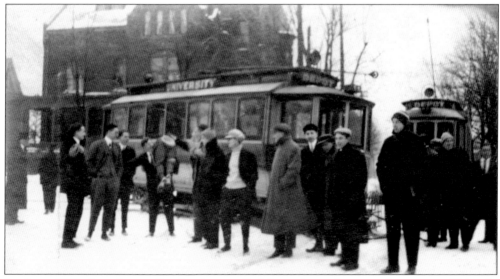

In about 1912, the other trolley has been called from the carbarn on the corner of Lincoln Avenue and Wells Street to rescue this trolley that jumped the track at the corner of State Street and South University Avenue. The excitement draws a crowd of students from the Psi Upsilon fraternity house in back of the trolley or from the Alpha Delta Phi and Sigma Chi fraternities across State Street. (Psi Upsilon File, Bentley Historical Library.)

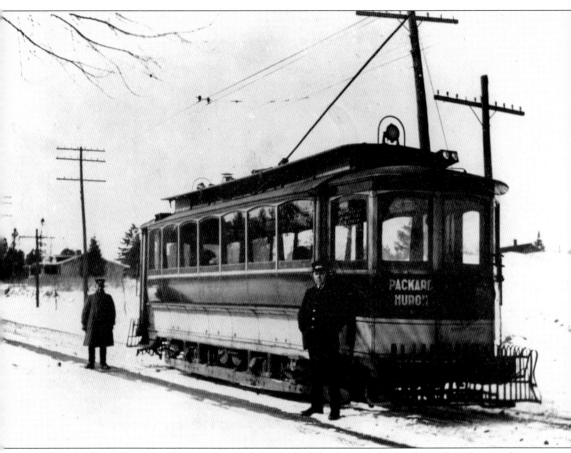

The Packard-Huron trolley has reached the end of the line on Packard Road at the city limits. The crew is posing for this winter photograph before it starts back. The conductor has flipped all the seats over so that they face the other direction. The motorman has removed his key from the controller and inserted it in the one at other end. Then he stepped out of the car, took the headlight off one end and hooked it over the straps on the other end, and plugged the wire into the receptacle. Meanwhile, the conductor has pulled the trolley off with the trolley rope and walked it to the other end of the car and placed it back on the wire. They would then board the car, and when the schedule said "time to go," they left. This image and those on the following page were given to author H. Mark Hildebrandt by Steve Duris.

An open car provided a breezy ride when the weather was hot. The conductor would then walk along the running board to collect 5¢ fares or six-for-a-quarter tickets. The motorman stands on the strap-iron fender, which prevents further injury if someone is knocked over by the sweeper. The car weighs about 20,000 pounds, and applying the hand or air brakes and reversing the motors in an emergency does not stop it very fast.

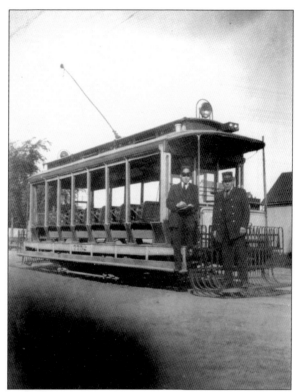

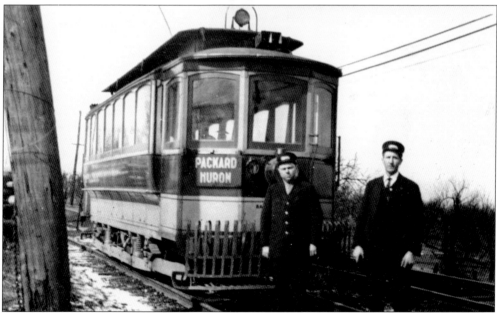

At the end of the Huron Street line, the trolley pulls into the Glendale siding at the top of the hill near present Veteran's Park. Passing sidings permitted cars to pass on single-track lines. Before they proceed, the conductor must call the dispatcher to get clearance to proceed back into town on the single track. Motorman Steve Duris is on the left, with conductor Harry E. Jeffrey on the right.

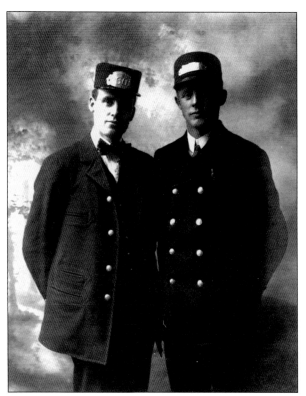

This trolley crew went into the White Photo Studio on East Huron Street to get its picture taken. The cap on the fellow on the right says "motorman," and the cap on the left fellow reads "conductor." The conductor has a vest and single-breasted blue serge jacket and plenty of pockets. The motorman has a watch chain in his lapel buttonhole and his watch in his upper pocket.

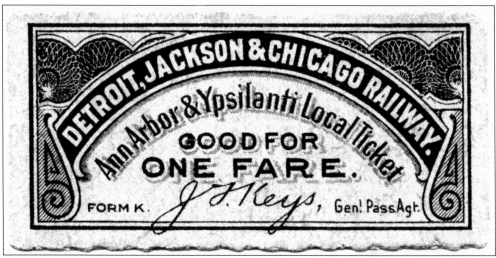

The Detroit, Jackson and Chicago Railway operated the local streetcars in Ann Arbor and Ypsilanti after 1907. The local fare was 5¢ or six tickets like this for a quarter. The tickets were also good on the large interurbans that ran every half hour or hour on Packard Road and Huron Street in Ann Arbor and Congress and Cross Streets in Ypsilanti. The local streetcars would stop at any corner, but the interurbans would only stop at a few designated streets.

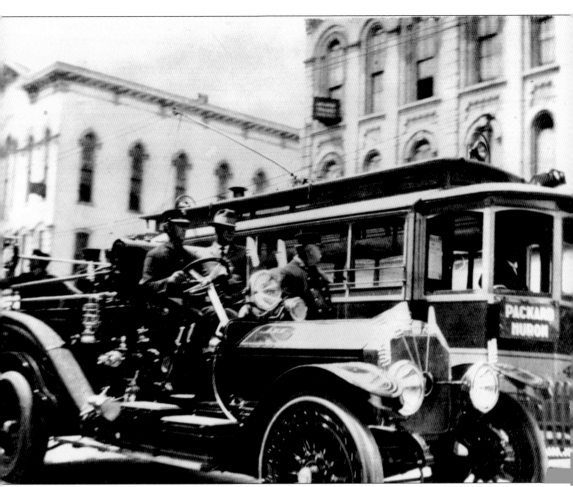

Ann Arbor trolley No. 453 and a shiny fire engine decked out with flags and officials roll across Washington Street on Main Street. Fire commissioner Sid Millard in a homburg hat is next to the driver. Police officer Isaac Shipley is on the running board. It is a very special parade. The trolley was built by the Stephenson Car Company for service in Flint in 1896. The Detroit United Railway moved it to Ann Arbor in 1916. Riders in Ann Arbor complained about the dinky old streetcars until they were replaced by buses in 1925. This image was given to author H. Mark Hildebrandt by Adaline Barbiaux.

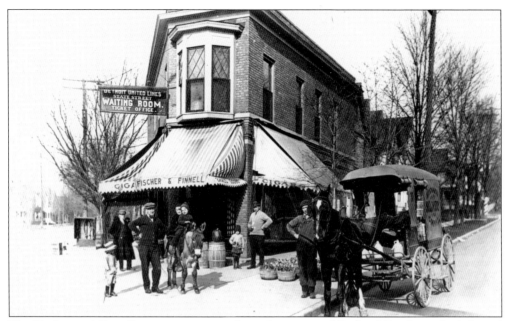

The Fischer and Finnell grocery store stood on the corner of Packard Road, on the left, and State Street, on the right. The sign on the left side of the building says "Detroit United Lines State Street Waiting Room, Ticket Office," which served the campus. The Merchants Delivery Company wagon standing by the curb is loading two bushels of apples. It must be the end of October around 1910. (Bentley Historical Library HS1676.)

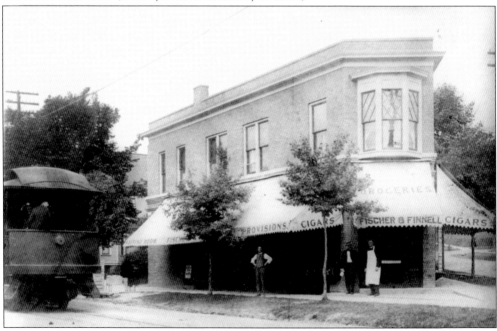

An interurban car has stopped at the Fischer and Finnell grocery store's Detroit United Railway State Street waiting room. A passenger is leaning on the railing of the back platform. In the middle of the back of the interurban car is the spring-loaded trolley-rope retriever. A clerk and two customers are watching the action. (Bentley Historical Library HS1722.)

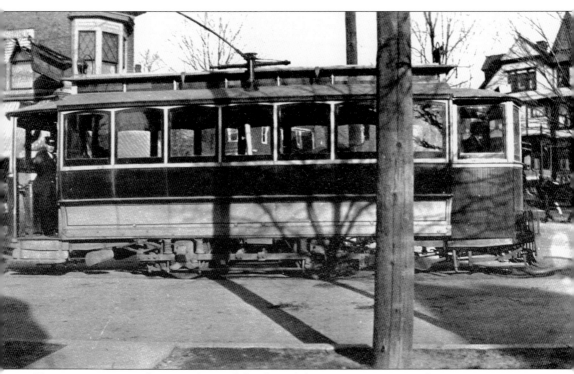

Here is a stunning side view of one of the Ann Arbor streetcars passing the grocery store on the corner of Packard Road and State Street. The conductor is standing on the back platform waving at the photographer. The stovepipe for the heater in the middle of the car can be seen on the roof. Above the rear platform is the sign for the Detroit, Jackson and Chicago Railway waiting room in the store on the corner. The store is now the Campus Corner Party Store. (Bentley Historical Library HS3684.)

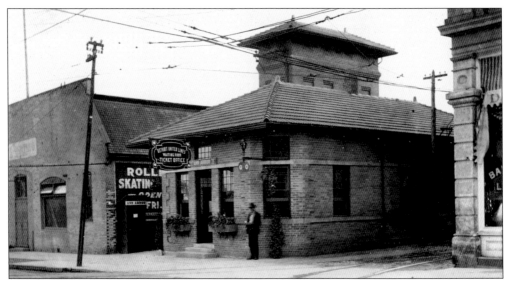

A trainman is standing in front of the Ann Arbor interurban station on Huron Street, one-half block west of Main Street. It is 1915, and the Coliseum Roller Skating Rink in the background, opened in the old armory building. The curved tracks on the right and left are the wye tracks that lead into the station. The semaphore indicates whether there is a train order from the dispatcher in Ypsilanti for the next segment of the line.

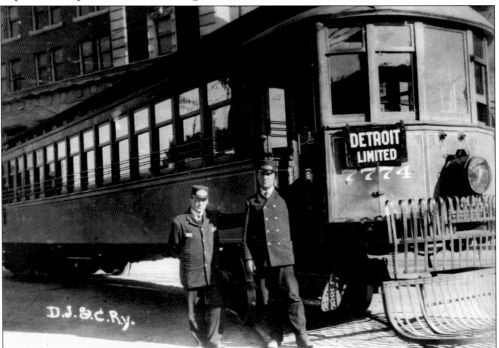

The motorman in his double-breasted coat and the conductor in his single-breasted coat pose by the front steps of interurban car No. 7774 in front of the Ann Arbor interurban station. In the background is the Glazier Building. The original 42-foot cars were not big enough to carry the increasing traffic. This longer 52-foot car was produced by splicing two shorter cars together. (Ypsilanti Historical Society.)

The Baltimore Cafe was right next to the interurban station in the Ann Arbor Savings Bank block (later the Municipal Court Building) from 1907 to 1909. Timetables for the Detroit, Jackson and Chicago Railway interurban line, the Michigan Central Railroad, and the Ann Arbor Railroad are on the back of Don F. Woodward's card. The Ann Arbor Railroad station was on South Ashley Street, and the Michigan Central Railroad station was at the north end of the Main Street streetcar line, which went down Detroit Street.

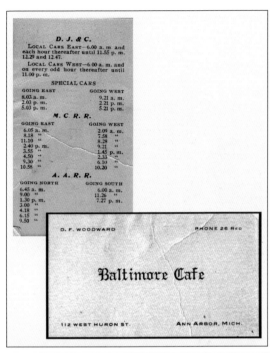

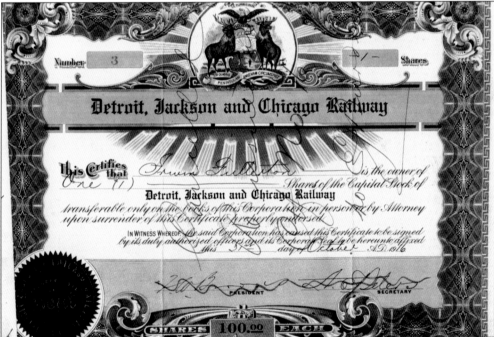

In 1907, the Detroit United Railway bought the Detroit, Ypsilanti, Ann Arbor and Jackson Railway and incorporated the Detroit, Jackson and Chicago Railway to operate the property. This is a stock certificate issued by the Detroit United Railway to replace shares of Detroit, Ypsilanti, Ann Arbor and Jackson Railway stock. When the line filed for bankruptcy in 1929, the court assigned operation to the Michigan Electric Railroad's John F. Collins as receiver. The railroad was abandoned and liquidated in 1929.

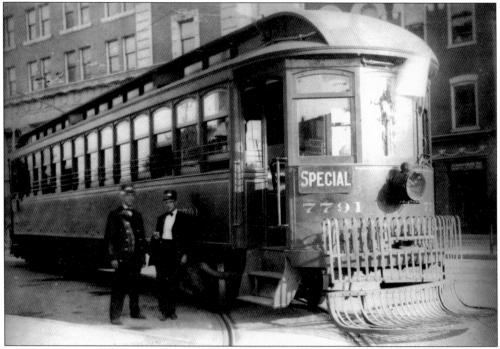

The crew of interurban car No. 7791 is relaxing by its car after a fast run from Detroit. This car is one of five 52-foot cars purchased by the Detroit, Ypsilanti, Ann Arbor and Jackson Railway in 1904 after completing the line to Jackson. The interurban car is on the curved track, which leads into the interurban station in Ann Arbor. The Glazier Building is in the background. The year is about 1915. (Ypsilanti Historical Society.)

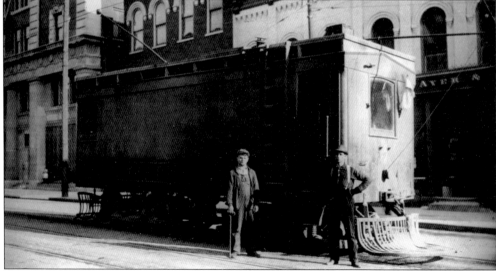

The Ann Arbor line car has stopped in front of the interurban station. Maintenance supervisor Pliny E. Skinner is seen with suspenders, standing on the right. The motorman on the left is holding a switching iron to turn the switch in the track in the street so that the line car can turn into the station track. There is a ladder beside the door of the line car so that one of the line crew can climb up to the platform on top. The year is about 1915. (Ypsilanti Historical Society.)

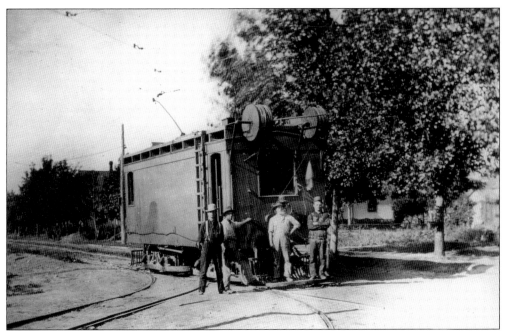

The Ann Arbor line car is standing in the middle of Lincoln Avenue in front of the Ann Arbor carbarn. The curving tracks in the foreground lead into the two bays of the carbarn. The carbarn was destroyed by fire on January 25, 1925. All the cars were saved. In this photograph, there are reels of trolley wire on the front of the line car and foreman Pliny E. Skinner is the worker on the far left.

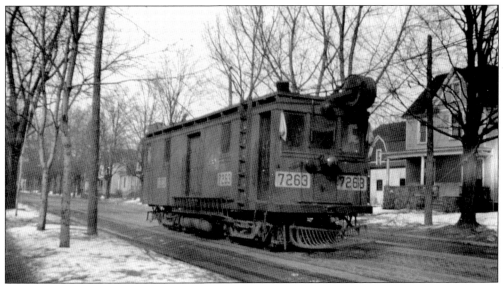

Detroit United Railway line car No. 7263, usually assigned to the Port Huron Division, travels down Packard Road near Wells Street in 1923. On this double-track section of Packard, as many as 20 interurban cars were lined up during University of Michigan football games in the Ferry Field Stadium on South State Street. After the game, every interurban was chock-full of football fans returning to Detroit. This image was given to author H. Mark Hildebrandt by Lloyd Morris.

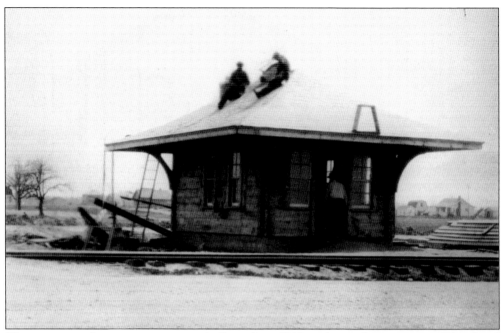

This new interurban waiting room was built in about 1912 on the southwest corner of Platt Road and Packard Road to serve the new Ann Arbor suburb growing in the background. The wide overhang of the roof and the large brackets make it unmistakable as an interurban waiting room. (Ypsilanti Historical Society.)

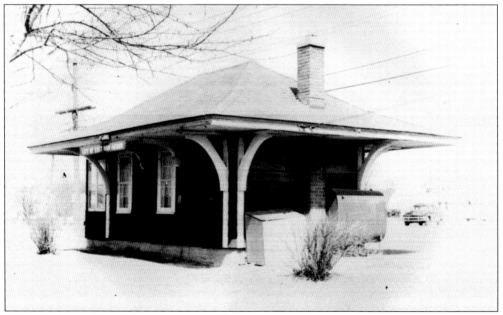

After the interurban tracks were torn up, the Platt Road waiting room stood empty. It was used as a barbershop for a while. When East Ann Arbor was incorporated as a city in 1945, the old interurban waiting room was converted into the city hall. East Ann Arbor was annexed to Ann Arbor in 1956. The site is now the location of a drugstore. This image was given to author H. Mark Hildebrandt by William Lewis.

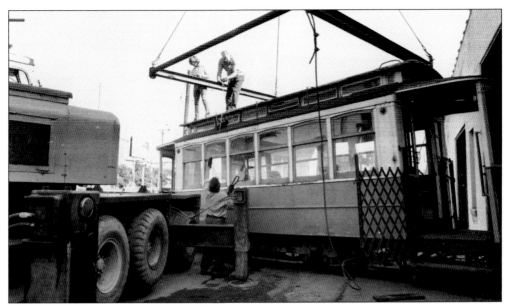

Single-truck trolley car No. 427 was imported by the Ann Arbor Trolley and Museum in 1976 to operate a heritage trolley line on Liberty Street between State Street and Main Street. It is being unloaded from a flatbed truck and eased into the Zahn's Garage building on First Street in Ann Arbor. The plan was studied extensively but eventually turned down by the Ann Arbor Transit Authority. (Photograph by Jack Stubs. Copyright 2008, The Ann Arbor News. All rights reserved. Reprinted with permission.)

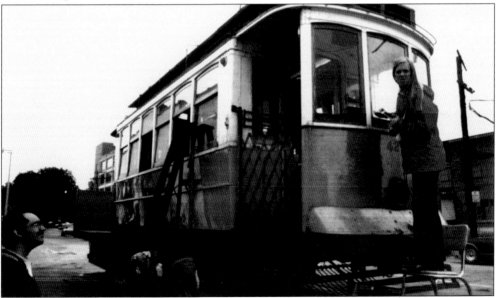

One of the members of the Ann Arbor Trolley and Museum, Mary Lou Slater wipes the front window of the imported trolley. The trolley is on a flatbed truck on First Street in front of the Zahn's Garage building. The trolley was built by the Brill Car Company in Philadelphia in 1907. It was in continuous service in Lisbon, Portugal, until 1976 when it was imported for operation on Liberty Street as a heritage trolley line. When funding failed, it was sold to Detroit. (Mary Lou Slater collection.)

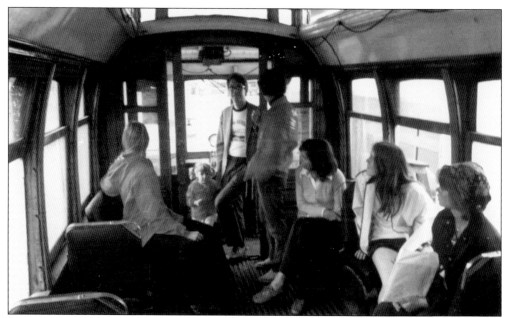

Members of the Ann Arbor Trolley and Museum and their families inspect the interior of their restored trolley in 1976. This was a semiconvertible car because the side windows could slide up into the ceiling on the curved tracks in the window posts, making it almost as open as an open car. One of the authors, H. Mark Hildebrandt, stands on the front platform with his daughter. (Mary Lou Slater collection.)

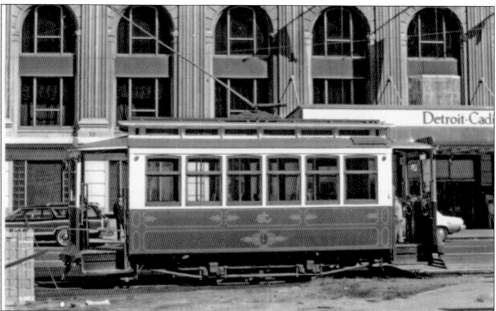

Ann Arbor Trolley and Museum's trolley was purchased by Detroit. It operated on a heritage trolley line from Washington Park to the Renaissance Center for several years as car No. 6. Here is car No. 1 in 1979, identical to No. 6, loading in front of the closed Detroit-Cadillac Hotel, now restored and reopened as the Westin Book Cadillac Hotel. The trolley line to revitalize downtown Detroit is no longer running. (Photograph by H. Mark Hildebrandt.)

Three

University of Michigan's Coal Trolley

Perhaps the least known of the electric railways in Washtenaw County is the University of Michigan's electrified industrial spur. In 1915, the university built a new power plant in the "cat hole" or hollow east of Fletcher Street. A railroad spur connected the new power plant to the Michigan Central Railroad main line in the Huron River valley to be able to deliver coal in hopper cars directly to the plant. The railway was built up a gentle grade along the side of the hill east of Glen Avenue, behind the houses that lined the upper part of Glen Avenue. It crossed Ann, Catherine, and Huron Streets at grade, then ran along the west wall of the powerhouse, over Washington Street on a bridge, and ended up a few yards from North University Avenue, adjacent to the University of Michigan Building and Grounds Building.

The university purchased a blue 50-ton electric locomotive from the General Electric Locomotive Company in Erie, Pennsylvania. The new locomotive used a pair of bow collectors on the top of the locomotive to take power from the two overhead wires. The bow collectors were mounted with double springs so that the locomotive could reverse direction without removing the collectors from the overhead wire.

Coal was dumped directly from the coal hopper cars into the storage area on the west side of the powerhouse. A traveling crane with a clam bucket could pick up the coal and pile it in large mounds or dump it directly into the power plant through funnels in the roof to feed the stokers for the boilers. The boilers provided steam that was piped through miles of tunnels under the campus to the university buildings.

The university de-electrified the railway in 1949 and purchased two small 35-ton U.S. Army surplus Plymouth switching locomotives. The electric locomotive was sold to the Warwick Electric Railway in Rhode Island and converted to diesel electric. It later moved to the Strasburg Railroad in Pennsylvania where it was eventually scrapped. The university replaced the Plymouth locomotives with an 80-ton General Electric U.S. Army surplus diesel locomotive in 1960. When the line was abandoned in 1969, the Port of Toledo purchased the diesel locomotive to switch the waterfront.

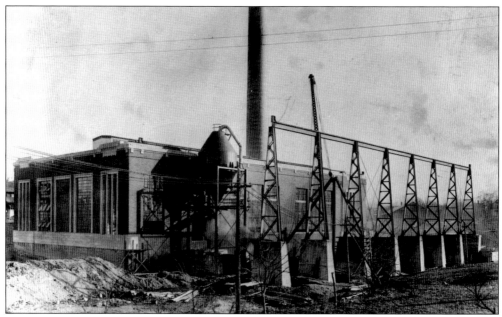

The new university power plant is under construction in this 1914 photograph. The railway line along the side of the building has not been completed, but the embankment can be seen piled up on the left side. The bulbous object below the smokestack is for ash storage. Ashes were then dumped into a railway hopper car and dumped in the ash heap at the valley end of the line. The power plant was enlarged in 1924. (Photograph by H. Mark Hildebrandt.)

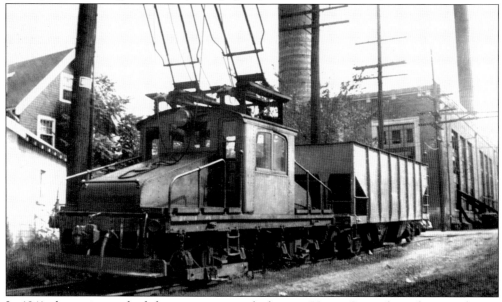

In 1941, the engine and ash hopper car are parked across Huron Street from the powerhouse. The red lamp hanging over Huron Street would blink on and off when the power was on for the electric engine to operate, warning automobile traffic to watch out for the train. A third-rail shoe, attached to the forward truck on the engine, picked up current from the third rail. An electrified third rail was beside the track at the switches in the rail yard at the valley end of the line. (Photograph by H. Mark Hildebrandt.)

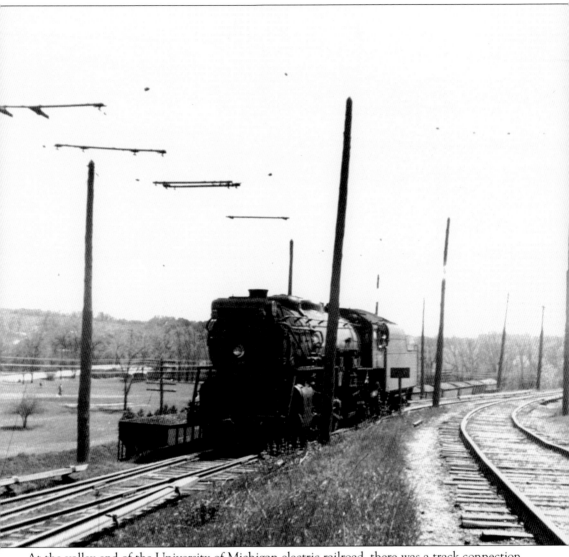

At the valley end of the University of Michigan electric railroad, there was a track connection with the Michigan Central (New York Central) Railroad. This freight engine has come up the connecting track to pick up empty coal cars from the electric line. It will take them back down, couple them into the train of full cars in the background, and then push them all back up onto the interchange track ahead of the engine, leaving the full cars to be hauled up the hill by the electric locomotive. The under-running third rail covered by a protective board is next to the switch of the interchange track. (Photograph by H. Mark Hildebrandt.)

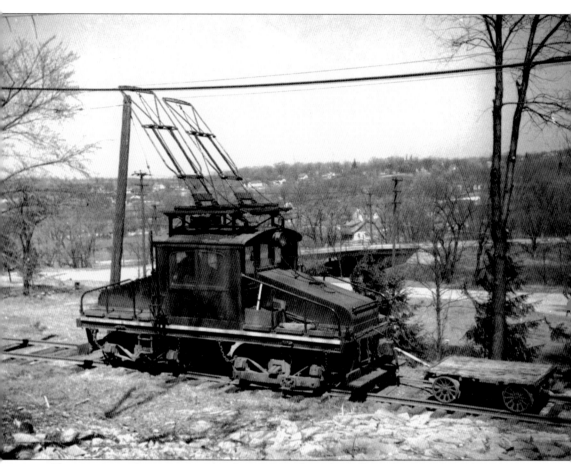

The university electric engine has been stopped on the hill overlooking the old Fuller Street bridge for a photograph in 1956. It is hauling a four-wheeled flatcar used in maintaining the railroad. The third-rail shoe can be seen on the arch-bar truck and the side-arm pickup is raised against the side of the engine. (Photograph by H. Mark Hildebrandt.)

The electric locomotive stands next to the powerhouse. There are no wires overhead. The side-arm current collector is down upon the electrified rail along the side of the powerhouse. The traveling crane piled the coal in the storage area and picked it up to dump it into a funnel in the top of the powerhouse. The coal fell into the automatic stokers, which fed the boilers to heat the university buildings.

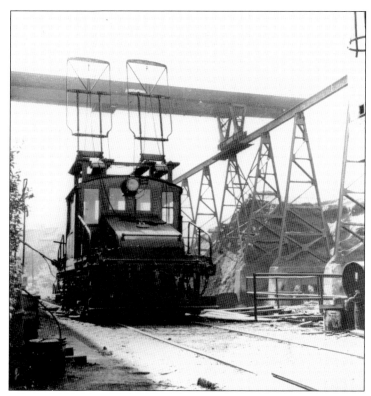

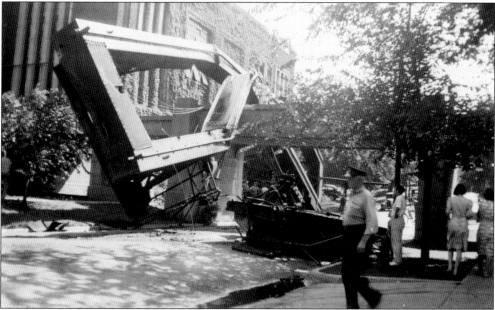

The traveling crane was blown off the top of the powerhouse in a June 1940 windstorm that spawned a tornado in Lakeland. The crane rolled to the end and crashed down onto the concrete bridge that spanned Washington Street, which at that time extended to Forest Avenue, now Washtenaw Avenue. Fortunately for the university, it was June and the demand for steam heat was minimal until a new crane could be installed. (Photograph by H. Mark Hildebrandt.)

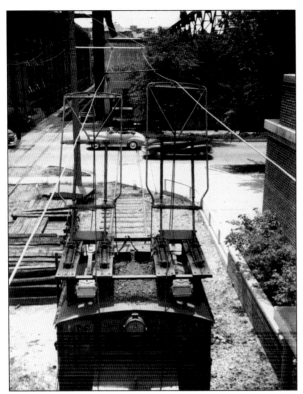

The bow collectors on top of the University of Michigan electric railroad locomotive were spring-loaded to press against the overhead wire regardless of whether the locomotive was going one way or the other. Cars are crossing the tracks of the line on Huron Street, and the powerhouse is in the background. The concrete structure across Huron Street is the ash-collecting building. Ashes were then dumped into a hopper car and hauled to the lower end of the line to be dumped in an ash heap. (Photograph by H. Mark Hildebrandt.)

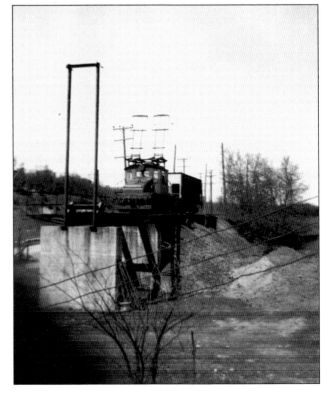

The University of Michigan electric locomotive has brought the hopper car full of ashes from the coal-fired boilers to the ash dump at the lower end of the line. On the left in the distance are the houses on Cornwell Place and Ingalls Street that overlooked the Huron River valley. (Photograph by H. Mark Hildebrandt.)

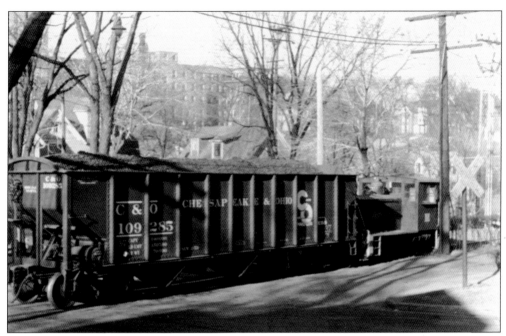

A dinky 35-ton Plymouth gas engine was purchased to replace the electric engine. It had a hard time getting up the hill with a loaded coal car. It had to take one at a time. Here it crosses Catherine Street with a Chesapeake and Ohio Railway loaded coal hopper car. In the background is the 1955 St. Joseph Mercy Hospital building. (Photograph by H. Mark Hildebrandt.)

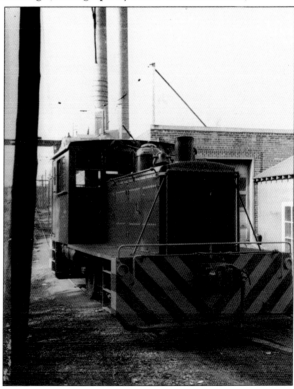

The university bought two surplus ex–U.S. Army 35-ton Plymouth gas locomotives, which were designed for switching freight cars. One was used in regular service; the other was available for spare parts if the first should need repairs. This is the second one, parked on the line south of the powerhouse. The building next to the engine is the university laundry building. The line ended about 200 yards south of here behind the Homeopathic Hospital, later the Naval ROTC building. (Photograph by H. Mark Hildebrandt.)

After a few years of struggling, the 35-ton Plymouth gas locomotives were replaced by an 80-ton General Electric diesel locomotive. This locomotive worked much better and continued to service the university railroad until after the power plant was converted from coal to natural gas. The food service building on the corner of Huron Street and Glen Avenue continued to get carloads of food hauled up the hill on the university's railroad until it was converted to a neuroscience research building. The railway was abandoned in 1969. (Photograph by H. Mark Hildebrandt.)

Here is the General Electric diesel locomotive working on the Port of Toledo Railroad to switch the waterfront after the university railroad was abandoned in 1969. One of its hoods has been removed. It was subsequently operated by Cargill in Ojibway, Ontario, and Decatur, Illinois. (Photograph by H. Mark Hildebrandt.)

70

Four

SALINE AND OLD MAUD

By 1897, the electric interurban railway between Ann Arbor and Ypsilanti had extended its line from Ypsilanti into Detroit, and big new electric interurban cars were carrying passengers between Ann Arbor and Ypsilanti and Detroit. On September 2, 1899, the Ypsilanti and Saline Electric Railway Company, a subsidiary of the Detroit, Ypsilanti and Ann Arbor Railway, completed an electric railway along the north side of Michigan Avenue (then Chicago Road) from Ypsilanti to Saline. The railway hoped to extend the line west to Adrian and even to Chicago. A shuttle car, affectionately called *Old Maud*, ran back and forth between Ypsilanti and Saline. Unlike the other interurban cars on the rest of the line, which had no space for packages and express, the shuttle car had a baggage and express compartment in front and a passenger compartment in back. It was called a combine, or combination baggage and passenger car. The motorman operated the interurban car from the front platform, while the conductor took care of the passengers in back, collecting fares, issuing fare receipts, and punching tickets. The interurban could be flagged to stop at road crossings along the way and sometimes could be stopped between regular flag stops. The flag stops between Saline and Ypsilanti were Town Line Road (now Bemis Road), Pease, Harwood, Cady, Robert, Crane, Payne, Canfield, Sherwood Road, Begole Corners, and Eedy. The electric interurban service to Saline came to an end on September 27, 1925, because the State of Michigan Department of Highways wanted to widen Michigan Avenue and pave it as U.S. 112 using tax dollars. This meant that the tracks of the interurban railway would have to be moved at company expense. Since the Detroit United Railway operated the line at a loss due to highway competition, it could not afford to move the rails. Instead, the branch line was abandoned.

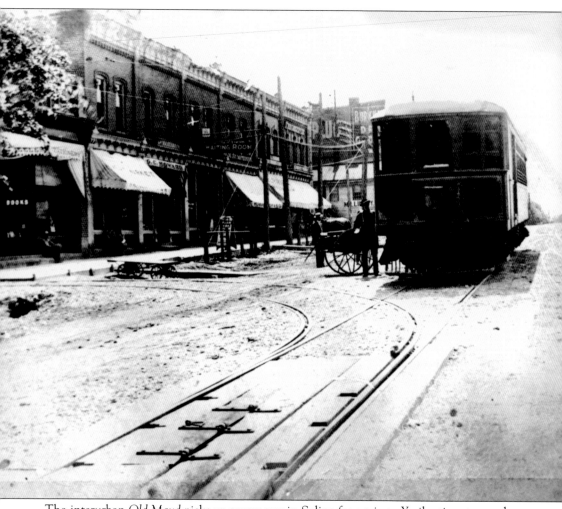

The interurban *Old Maud* picks up passengers in Saline for a trip to Ypsilanti, or to nearly any place in between. The year is about 1901. The waiting room sign is visible, projecting out of the building about mid-block on the left. It says, "Detroit, Ypsilanti, Ann Arbor and Jackson Railway." Just to the left of the waiting room, a grocery market and bookstore are both handy for passengers awaiting their ride. A low four-wheeled wagon sits next to the sidewalk for luggage or packages. *Old Maud* is facing east for this picture, ready for the trip to Ypsilanti. On the front of the interurban is the people catcher, or strap-iron sweeper. An electric headlight is in the middle of the front of the car, with a shade above it to roll down to reduce brightness. With five windows across the front, this car was manufactured in 1901 by the Barney and Smith Car Company of Dayton, Ohio, so it was a new car in this photograph. Hinged wooden planks in the foreground covered the switch for running a car into the station siding. (Saline Historical Society.)

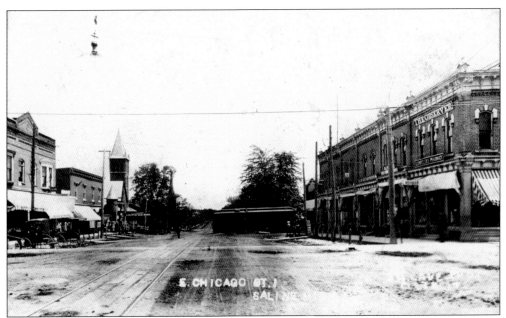

In 1901, the photographer shot this postcard view facing east toward Ypsilanti. This view shows the center of Michigan Avenue (East Chicago Street in the photograph). The interurban passenger waiting room is on the right, four shops down from the corner, but it does not have its sign hung yet. On the left are the sign of the livery and feed store and the turret and steeple of the Presbyterian church.

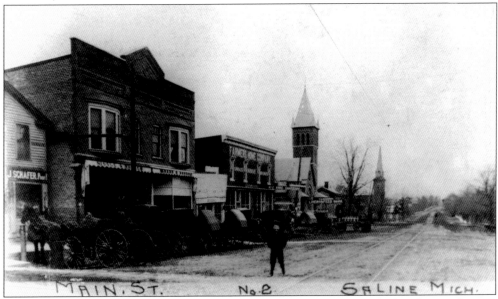

In about 1905, businesses on the north side of the Chicago highway displayed signs showing off their merchandise. A local boy apparently spotted the photographer and ran into the street to be in the picture. Beyond the steeple of the Presbyterian church is the tall steeple of Trinity Evangelical Lutheran Church on the corner of Harris Street and Michigan Avenue. Trolley tracks dominate the center of the street, and the trolley wire hangs overhead. (Saline Historical Society.)

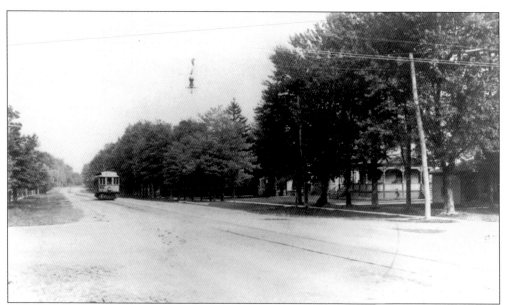

The Saline interurban *Old Maud* approaches town from Ypsilanti. The view is from the corner of Harris Street and Michigan Avenue. The Lutz Queen Anne–style house, built in 1907, is on the right. The light color of *Old Maud* shows that it has been repainted. The Detroit, Ypsilanti, Ann Arbor and Jackson Railway was taken over by the Detroit United Railway in 1907. The new company colors were scarlet body, black trim, and gray roof. The film at that time showed scarlet as light gray.

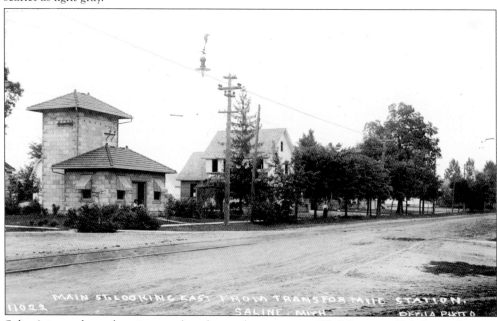

Saline's interurban substation stood on the northeast corner of Hall Street and Michigan Avenue. It contained a rotary converter and transformer to convert transmission voltage from 22,500 volts AC to 600 volts DC to power the trolley wire. Other substations on the line were similar tile-roofed, square buildings with a tower on the side. This one was built with hollow building tile instead of brick. Today a fire station is located there. (Photograph by Louis J. Pesha.)

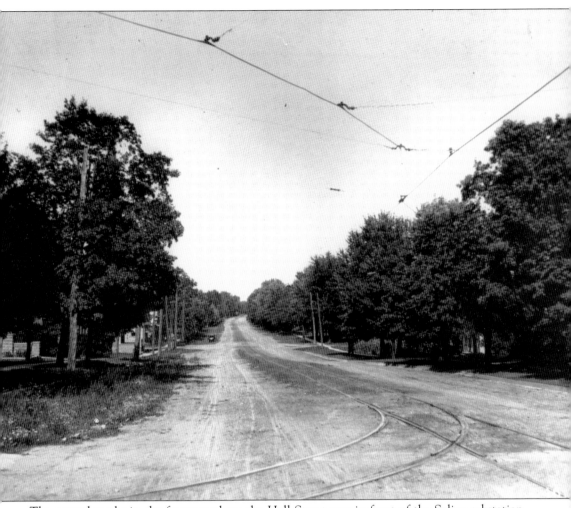

The curved tracks in the foreground are the Hall Street wye in front of the Saline substation around 1907. Another curved track behind the photographer allowed an interurban car to reverse direction by going forward into the wye and backing out the other arm of the wye. A motorcar is seen parked on the left side of the street a block away. (Saline Historical Society.)

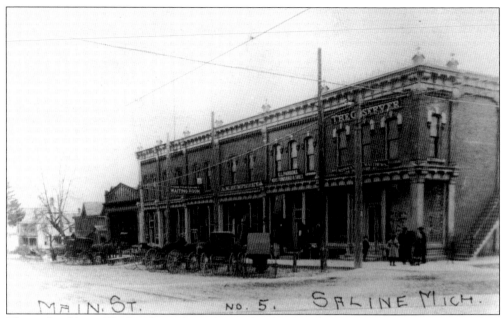

The six-bay Union Block still stands on the south side of Michigan Avenue. In 1901, buggies line the dirt street in front of the shops. A four-wheeled wagon for baggage is parked in front of the interurban waiting room in the fourth bay, under the sign "Detroit, Ypsilanti, Ann Arbor and Jackson Ry. Waiting Room." The shop on the end with the peaked roof is a bookstore. (Saline Historical Society.)

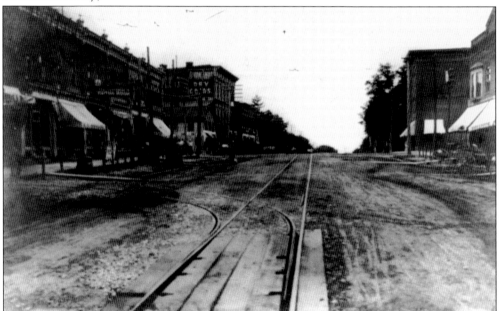

Interurban tracks run straight up the middle of Saline's main street. Saline-Ann Arbor Road crosses Michigan Avenue at the crest of the hill. In the foreground the station siding curves off to the left. This siding served to load passengers or unload package freight from express cars. The interurban station is under the waiting room sign on the left. The old interurban track is still there, under the pavement. (Saline Historical Society.)

A fare receipt says everything about the rider's trip on the interurban. This one was punched after the fare was paid. Along the bottom of the receipt is the name of the line: Detroit, Jackson and Chicago Railway. The ticket was issued after 1907, when Detroit United Railway purchased the Detroit, Ypsilanti, Ann Arbor and Jackson Railway and operated it as the Detroit, Jackson and Chicago Railway. On the left side, "East Bound" shows that the rider was headed east. This fare receipt could have been used for the Ypsilanti–Saline branch or the Wayne–Plymouth–Northville branch. Ann Arbor and Ypsilanti have been punched, and 15 was punched in the fare column to show that the rider paid 15¢ for the ride from Ann Arbor to Ypsilanti. The month of the trip, December, is punched at the top and the day of the month, 1, is printed in a circle at the bottom left corner. The back of the receipt contains a warning that no one can use the receipt except the person to whom it was issued.

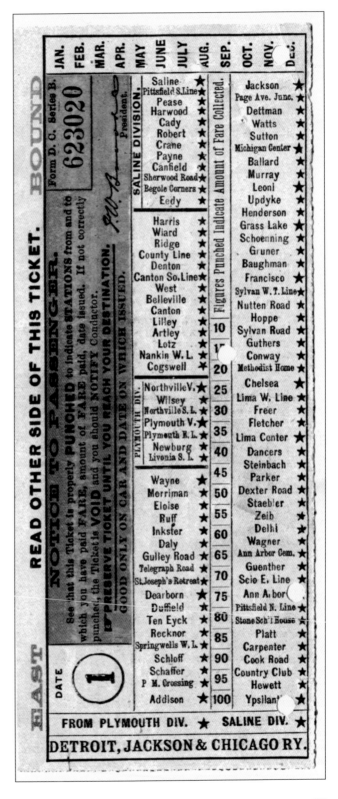

77

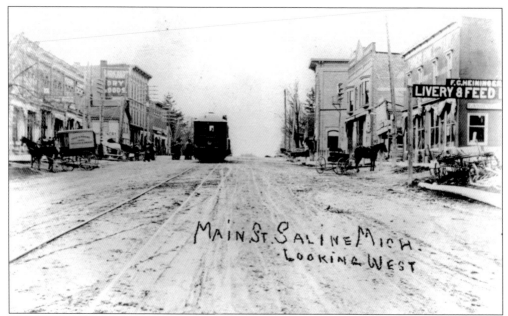

This view, facing west in 1901, shows *Old Maud* loading passengers in the middle of the street. Saline did not have local streetcars. The interurban was larger and more comfortable than a streetcar and was intended for longer trips. Note the livery and feed store on the right and the grocery wagon on the left. Some could not afford a horse, but just a few cents bought a ride into Ypsilanti. (Saline Historical Society.)

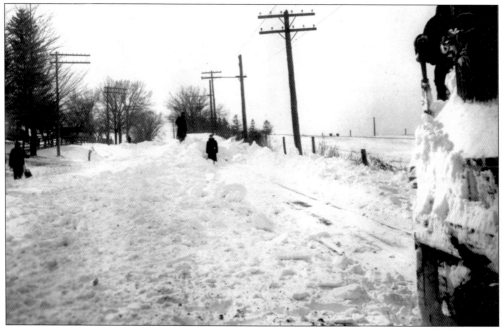

Saline was hit by a serious snowstorm in February 1912. The Detroit United Railway sent plow work car No. 7804 to clear the line. However, even with the plow car, they could not get through. Two men with determination are up ahead on top of the six-foot drift with snow shovels, trying to reduce the drifts. This photograph was taken east of Town Line Road (now Bemis Road).

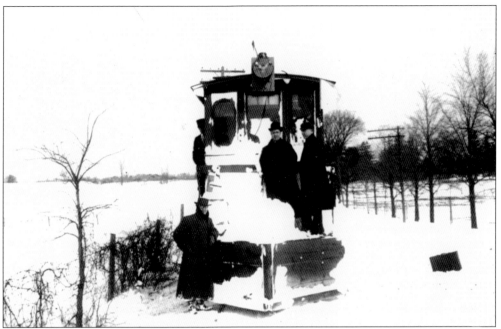

Even with a snowplow, the February 1912 snowstorm was challenging for the interurban between Saline and Ypsilanti. The officials on the plow project stand on the snowplow for an official picture to commemorate the occasion. The photograph negative was No. 1180 in the Detroit United Railway photo album.

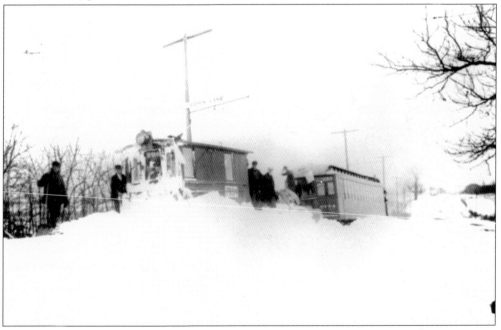

A photograph from the February 1912 snowstorm shows plow car No. 7804 and passenger car No. 7774 for the interurban railway officials. The car stop sign on the pole behind the plow car says "Town Line," which is now known as Bemis Road. The Detroit United Railway, which operated the Saline line, obviously wanted to keep the line open no matter what.

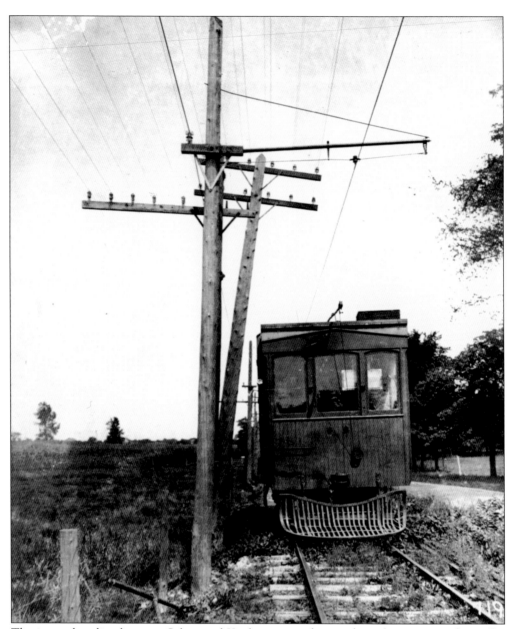

The interurban line between Saline and Ypsilanti carried more than electric interurbans. On August 25, 1908, the Detroit United Railway sent out a line car for an inspection. This work car, No. 7813, was equipped with a platform on top so that workmen could reach the overhead wires. This company photograph, facing east, led the Detroit, Jackson and Chicago Railway to complain to the Postal Telegraph Company. The telegraph company's pole carrying the telegraph wires is seen leaning toward the interurban's space. The telegraph company was a private business, renting space for its poles. The other pole with the offset crosspiece carrying a darker cable and the bracket for the overhead trolley wire belongs to the interurban line. The cable carries the high-voltage power to the interurban substation on Hall Street in Saline. The telephone wires visible on the offset crosspiece carry the wires of the interurban's private telephone system The trolley pole on the work car contacts the overhead trolley wire for power.

Five

CHELSEA, GATEWAY TO THE WEST

When electric railways were in vogue, Chelsea was seen as a gateway to the west. Passengers in Ann Arbor and Ypsilanti took the interurban cars to Detroit for the first time in 1898. Three short years later, James D. Hawks and Samuel F. Angus, Detroit investors, built an interurban railway through Chelsea on the way to Jackson. The Chelsea passenger station along South Main Street was built about a block south of the downtown. The railway was called the Detroit, Ypsilanti, Ann Arbor and Jackson Railway. Interurban electric cars from Ann Arbor traveled west along Jackson Road to reach Chelsea.

Suddenly Chelsea found itself in the center of an interurban battle, with two competing companies laying tracks through the town. The second company, Detroit and Chicago Traction Company, was set up by William A. Boland of Jackson. His interurbans depended on a third rail for travel in rural areas. Electricity was sent through an extra rail to the side of the main rails. Boland obtained a franchise to lay rail from Chelsea to Dexter along the Chelsea-Dexter Road. From Dexter to Ann Arbor, he followed Miller Road. His franchise allowed interurbans to go through the center of downtown Chelsea along Middle Street. He laid tracks and installed an overhead electric trolley wire through town. In 1901, Boland made a trial journey from Grass Lake to Chelsea. A steam locomotive was used because the line was not electrified. Then the Boland construction stopped. Six years later, the Detroit United Railway bought all of Boland's franchises east of Grass Lake, including Chelsea, and the incomplete rail lines. The Detroit United Railway also bought the Detroit, Ypsilanti, Ann Arbor and Jackson Railway from the Hawks and Angus group. That sale included the interurban station on the southern edge of Chelsea's downtown. Starting on January 18, 1902, interurbans could leave the Chelsea station and travel to Grass Lake and on to Jackson. Another interurban company handled travel on the west side of Michigan, making it easy and inexpensive to take local trips or longer journeys. After 1911, people living in Washtenaw County could travel to Battle Creek, Kalamazoo, and Lansing on the interurban system because the Michigan Electric Railway west of Jackson cooperated with the Detroit, Jackson and Chicago Railway by running through cars every two hours during the day.

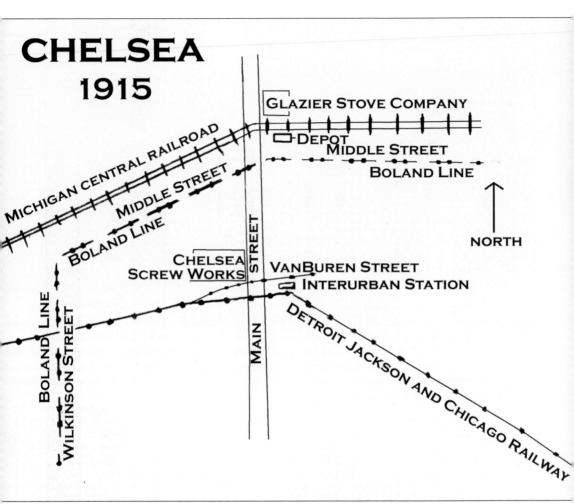

CHELSEA
1915

GLAZIER STOVE COMPANY

MICHIGAN CENTRAL RAILROAD

DEPOT

MIDDLE STREET

BOLAND LINE

MIDDLE STREET

BOLAND LINE

NORTH

CHELSEA SCREW WORKS

VANBUREN STREET

INTERURBAN STATION

MAIN STREET

BOLAND LINE

WILKINSON STREET

DETROIT JACKSON AND CHICAGO RAILWAY

Chelsea's Glazier Stove Company created plenty of jobs for residents in and near Chelsea. It is shown on this 1915 map just north of the Michigan Central Railroad, the steam railroad. East of Chelsea, the Boland electric railway line was built just south of the steam railroad tracks. Between Grass Lake and Chelsea, it was graded on the north side of old U.S. 12. The Boland cars never ran through Chelsea. The Detroit United Railway offered electric rail service through Chelsea. Its station was just south of the downtown on Van Buren Street. The Chelsea Screw Company works is shown on this map across Main Street from the station. (Authors' collection.)

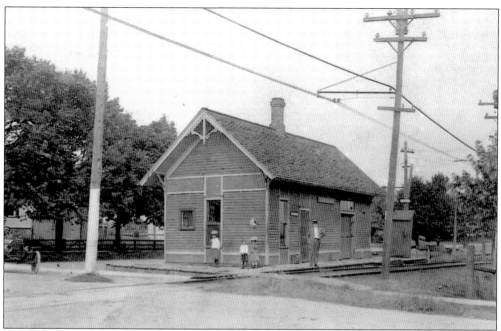

Several people gather at Chelsea's first interurban station around 1909. Wooden poles support the overhead trolley wires and the power line for the interurbans. Decorative trim on this simple 1901 building are reminiscent of Victorian style. Note the Ford Model T on the left edge of the photograph. (Chelsea Area Historical Society.)

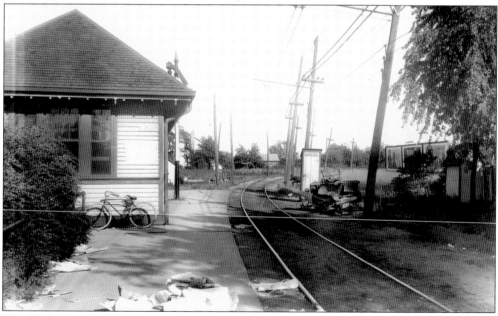

The Chelsea interurban station (shown here in about 1915) opened for business in about 1910. It replaced an earlier building. In about 1915, a photographer took this photograph while standing close to Main Street and facing east. Out-of-town newspapers were delivered the same day by the interurban. The newspaper wrappers are seen strewn around near the tracks. The sign on the wall reads, "Detroit United Lines, Enjoy your trolley trip." (Chelsea Area Historical Society.)

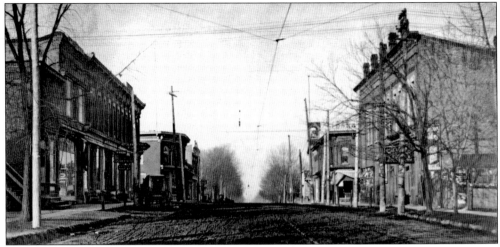

In about 1902, Middle Street in downtown Chelsea was dominated by trolley wire above and tracks down the middle of the street. William A. Boland laid the track and installed wire for his Detroit and Chicago Traction Company. The track lies half-buried in the mud. No electric car ever ran. (McKune Public Library, Chelsea.)

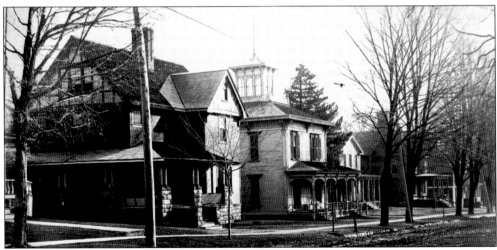

William A. Boland of Jackson came very close to running a second interurban line through Chelsea. He owned franchises to connect Jackson to Ann Arbor, and he constructed his line through Chelsea. This scene shows 131 East Middle Street in Chelsea in 1921, with unused trolley wires visible above the street. The trolleys never ran. This house still stands, but the house to the right is gone. (McKune Public Library, Chelsea.)

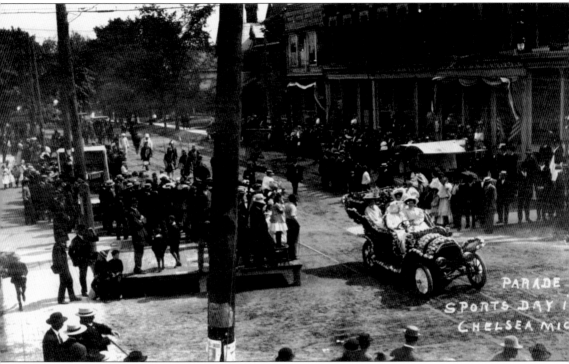

Ladies in white dresses and huge hats drive their parade float down Middle Street in Chelsea, the main east–west drag. The year is 1908, and they are driving, literally, on top of some abandoned rails meant for an interurban line. These rails, part of the Boland line, were intended to continue east through the cemetery and on to Dexter, south of the Michigan Central Railroad tracks. The railway was never finished. Just south of Chelsea's downtown, on Van Buren Street, the Detroit, Jackson and Chicago Railway offered a waiting room for passengers who wished to take an electric railroad. Chelsea came close to having two different interurban railways in town, as well as the steam railroad. (Chelsea Area Historical Society.)

This photographer took a great shot of the railroad tracks covered by dirt. Looking down Middle Street in Chelsea, a child is seen about half a block away. William A. Boland took one test run on his interurban line from Grass Lake to Chelsea in 1901, right through this neighborhood. A steam engine pulled the car because the electricity was not connected. His rail ran west from Chelsea along old U.S. 12 to Grass Lake. His Grass Lake-to-Jackson line continued to operate for many years. (Bentley Historical Library HS3540.)

The Boland line was finished in downtown Chelsea but never operated. Beyond Chelsea, Boland graded the land to prepare for rails to carry the interurbans. Once the earth is moved around to make a level area, it stays that way for years to come. This is a scene east of Dexter as it appeared in 1974, clearly showing a cut to accommodate the Boland interurban line. (Photograph by H. Mark Hildebrandt.)

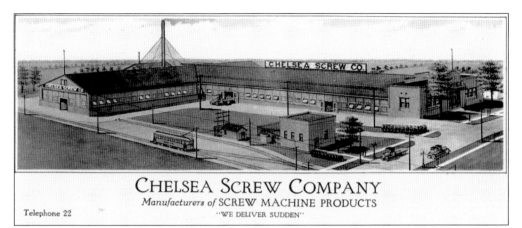

CHELSEA SCREW COMPANY
Manufacturers of SCREW MACHINE PRODUCTS
"WE DELIVER SUDDEN"

Telephone 22

This stylized advertising card for Chelsea Screw Company shows a diminutive interurban car leaving the Chelsea station headed for Jackson. The trolley is a cream color with dark green trim. The screw company occupied the west side of South Main Street, across from the interurban station. The *DJ&C* on the trolley refers to the Detroit, Jackson and Chicago Railway, a division of the Detroit United Railway.

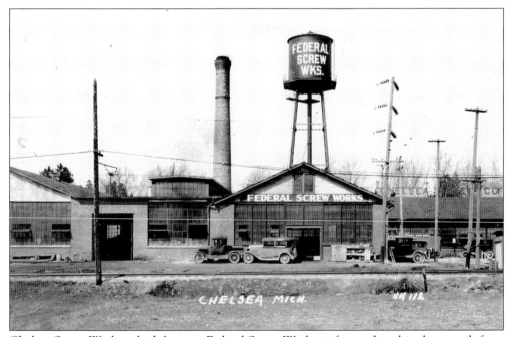

Chelsea Screw Works, which became Federal Screw Works, is featured in this photograph from about 1928. The view faces north. The interurban track in the foreground was still in use when this picture was taken, so the date had to be before September 1929, when the last car ran. (Chelsea Area Historical Society.)

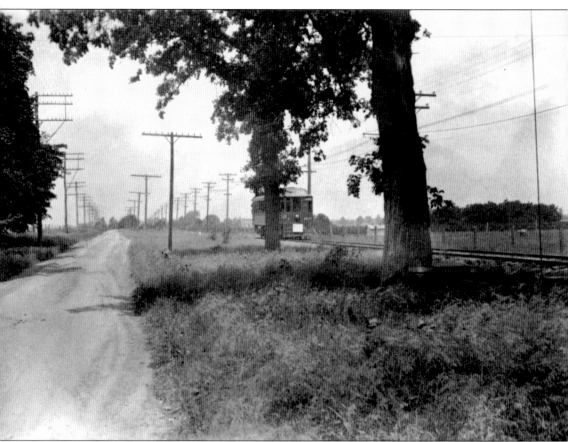

The interurban line runs along the north side of Jackson Road in front of the Pielemeier farm in Lima Township just four miles east of Chelsea. Seen here in 1912, Jackson Road is still unpaved. A wooden seat is seen alongside the tree on the right, and there is a swing to entertain children while waiting for a trolley ride. This was known as the Pierce stop for the family that previously owned the farm. (Dorothy Frielandville Collection, Bentley Historical Library HS3173.)

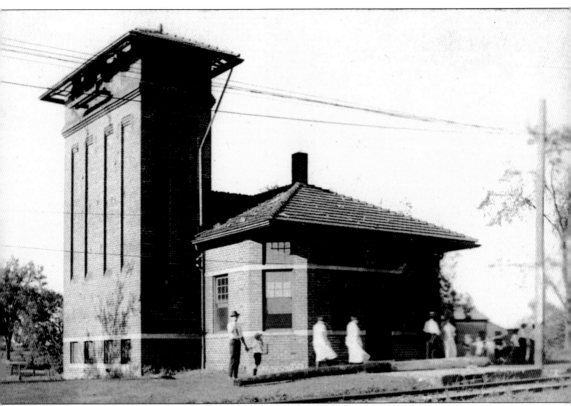

In 1901, the Detroit, Ypsilanti and Ann Arbor Railway opened service to Chelsea. This photograph was taken within a few years after it was built. Interurban cars from Ann Arbor traveled along Jackson Road and stopped here at Lima Center on their way to Chelsea. This passenger station doubled as a waiting room and substation, containing a transformer to supply 600-volt DC power to the interurbans. (George B. Sparrow.)

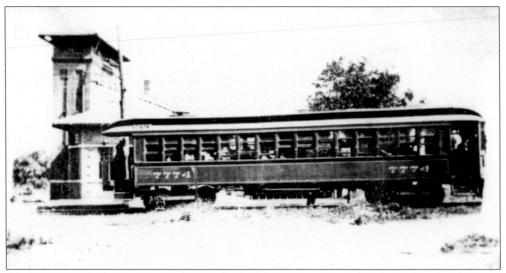

Chelsea enjoyed plenty of interurban traffic in the early 1900s. This 1918 photograph shows interurban No. 7774 of the Detroit, Jackson and Chicago Railway at the Lima Center station, three miles east of Chelsea. The passengers are cooled by the breezes from the open windows. They will be in Ann Arbor within half an hour. (George B. Sparrow.)

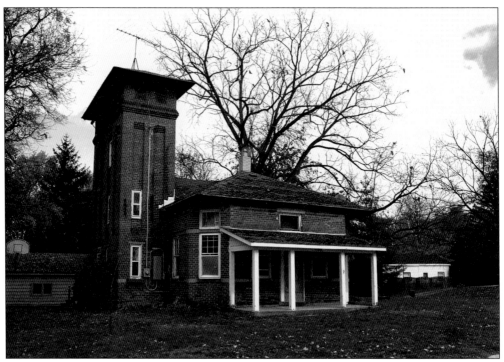

The only interurban substation still standing in this area, the Lima Center landmark is a classic. Old atlases of the area show Lima Center as a shopping and commercial district, but today farms are the main activity. Past owners of this building have added a porch and changed the roofing materials. From the outside, it is the same as always. The building is now a residence. (Photograph by Martha A. Churchill.)

Several men in smart suits wait for a ride at the open waiting room at Sylvan Road, about three miles west of Chelsea. The Detroit, Jackson and Chicago Railway went west from Chelsea, alongside the steam railroad tracks to Grass Lake. The photographer labeled this waiting room the "Cavanaugh Lake Station," but it was actually a two-mile walk to the lake. (McKune Public Library, Chelsea.)

Eugene Smith wanted people to think of the Sylvan Lake interurban stop as the way to his Kavanaugh Lake Summer Hotel for fishing, swimming, and boating. He placed this advertisement in the 1915 *Washtenaw County Atlas*. He was ready for automobile parties, and he provided a feed barn for those arriving by buggy. "I also have buss to meet Electric Car at Sylvan Sta'n., I will treat you right," he promises. (Milan Public Library.)

Even a tiny burgh like Francisco managed to boast two train stations in 1905 as shown by this postcard. Francisco was less than a mile west of Washtenaw County. The white building housed the steam railroad station for the Michigan Central Railroad. Behind it stands the dark brick waiting room and substation for interurban passengers. Each railroad owned a complete set of buildings, tracks, and cars. Two separate worlds, side by side.

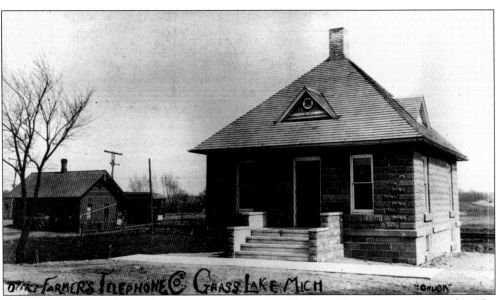

The main subject of this 1910 picture is the Farmer's Telephone Company in Grass Lake. The picture does double duty by showing the Grass Lake station of the Detroit, Jackson and Chicago Railway. On the left, an interurban is standing at the station, while a team of horses and a wagon are parked on the near side of the station. Note that the detail on the roof is similar to the first interurban station in Chelsea.

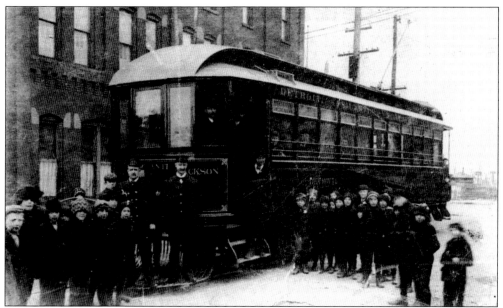

In spite of the bitter cold, someone called in a photographer and about 22 schoolchildren for this important occasion. It is January 18, 1902, and the first Detroit, Ypsilanti, Ann Arbor and Jackson Railway interurban car has arrived in Jackson. With its main offices located in Ypsilanti, this railway had reached Jackson at the far western end. Passengers could continue westward on the Jackson and Battle Creek Traction Company in 1903 and north to Lansing on the Lansing and Jackson Railway in 1906.

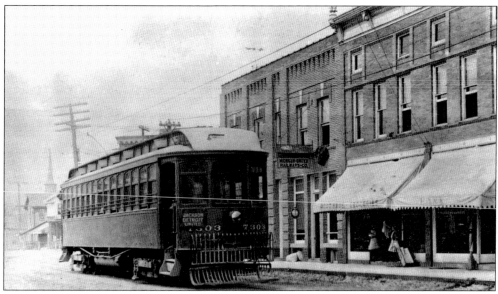

Several women stand under the awning of the Root Brothers grocery store in Galesburg, between Kalamazoo and Battle Creek. An interurban car owned by the Detroit, Jackson and Chicago Railway pulls up. It is 1925, and Michigan United Railways on the west side of Michigan cooperated with the Detroit United Railway, running through cars from Detroit every two hours. This interurban would continue all the way to Detroit, stopping at major stations only.

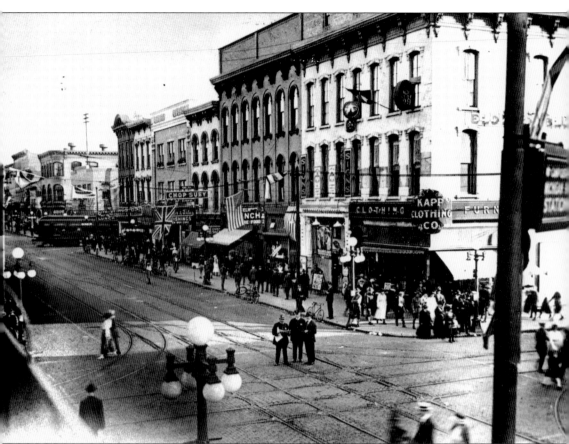

Leaving Chelsea on a westbound limited, a passenger could go through Grass Lake to Jackson, then continue on to Battle Creek and Kalamazoo. On September 1, 1918, Battle Creek celebrated the community's first gasless Sunday. This was a gala event because previously gaslights were used on the streets, and now the town was switching over to electric streetlights. This view of Capital Avenue and Michigan Avenue facing east shows a Detroit, Jackson and Chicago Railway interurban pulling out of a side street. Note the numerous tracks for interurbans or streetcars crossing the intersection. Any of the people in this photograph could hop on the interurban, pay a few coins, and ride as far as Chelsea, Ypsilanti, or Detroit without any advance reservation. (Frank Angelo Collection, Bentley Historical Library HS3161.)

Six

MILAN, ON THE MAP TO TOLEDO

While interurban lines expanded from Ypsilanti both east and west, investors longed for a line from Toledo north through Milan to Ann Arbor. By 1903, the Ohio and Michigan Traction Company was incorporated to build such a line. Before the company could lay tracks, it ran out of money. In 1904, it was sold to another company, the Toledo, Ann Arbor and Detroit Railroad Company. The new investors, meanwhile, made wondrous promises to communities like Milan, Dundee, and Ann Arbor. New interurban cars were ordered from Niles Car Company in Ohio. They would be fast, clean, and equipped with all the modern conveniences such as a smoking section, a toilet, and electric heat. The franchises were purchased, with the right-of-way extending straight north from Dundee to Milan, then curving along the east side of Milan to Stony Creek Road and Platt Road. From there, the railroad planned to lay track along the east side of Platt Road for a straight shot north to Ann Arbor. However, the system went through another name change in 1906 due to financial troubles. It was sold to the Michigan, Ohio, and Indiana Railroad Company.

The new company set poles from Sylvania, Ohio, almost to Petersburg and started a powerhouse in Petersburg. It graded a roadbed and poured concrete bridge abutments almost all the way to Ann Arbor. The interurban promoters stockpiled huge amounts of rail and steel in Petersburg for bridges to finish the line through Milan. The project went belly-up again in 1908. Reorganized in 1912 as the Toledo, Ann Arbor and Jackson Railway, steam trains operated on the nonelectrified line from Toledo to Petersburg. The competing Ann Arbor Railroad, afraid of losing passengers to the interurban, bought five gasoline-powered McKeen railcars in 1911. A McKeen car, streamlined ahead of its time, could make frequent stops and otherwise act like an electric. The Ann Arbor Railroad may have fooled some people into thinking it was an electric trolley. The two main types of traction, steam and electric, were locked in battle. As it turned out, the rush for electric traction was cooling. Milan never got its interurbans. Soon the surrounding towns lost theirs. But it was such a close call.

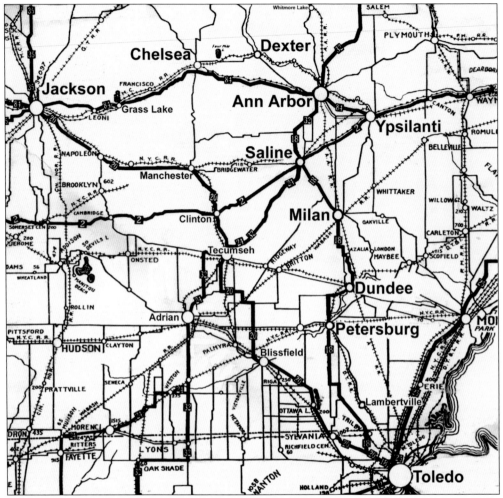

A road map in 1915 also shows the steam and electric rail service in Washtenaw County at the time. Steam railroads are shown with a crosshatched line, while electric interurbans are drawn as a line with round dots. Note that a person in Petersburg could take the train south, go through Lambertville, and end up at a streetcar stop on the west side of Toledo. That line, called the Ragweed, was supposed to be electrified but never was. The line from Petersburg to Dundee was never electrified either, although a station was built in Dundee for the Ragweed. As this map shows, it was a straight shot north from Dundee to Milan, and then to Ann Arbor, connecting all the dots. The line from Petersburg to Dundee was completed and purchased by the Detroit, Toledo and Ironton Railroad (steam). Milan residents saw plenty of interurban construction as cement abutments were poured, but no electric cars ever ran.

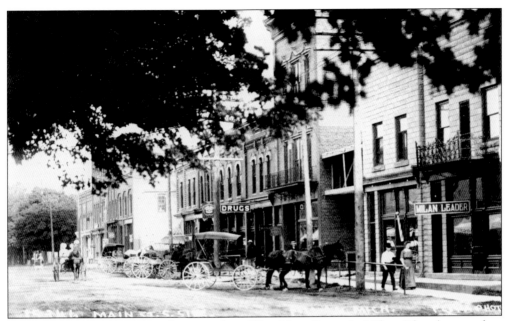

It was easy to shoot a postcard picture from West Main Street in Milan. The photographer, Louis J. Pesha, was facing east toward the main intersection of town. Horses and buggies parked along the street show that this town was a commercial center in about 1900 or 1905. Milan seemed like the right kind of place to include on an interurban line connecting Ann Arbor to Toledo. (Milan Area Historical Society.)

Arleigh Squires, a well-known businessman in Milan, was born in 1897 on a farm south of Milan. When he was 17, he quit college to take a job with a large company in Detroit. Every week he rode "the electric" to go home for the weekend. The photograph above shows him in about 1905, seated on the right with his parents, Asa and Alice, and his sister Carrie. His brothers, standing from left to right, are Jerome, Ransom, and Ernest. (Milan Area Historical Society.)

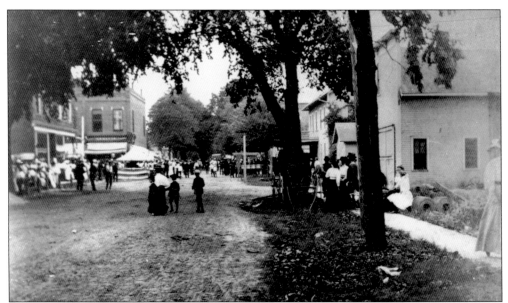

At about the dawn of the 20th century, Petersburg had its share of lovely ladies in long dresses going for a stroll on a nice day. This postcard features some festival underway in the downtown area. The town sits alongside the River Raisin. Petersburg was connected to the outside world by the Southern Railroad built by the State of Michigan in 1840 between Monroe and Adrian. Later it became the Lake Shore and Michigan Southern Railroad. (Monroe Historical Museum archives.)

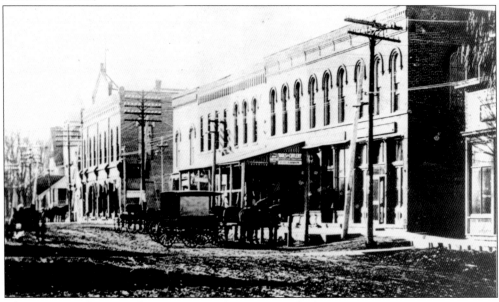

The commercial area in downtown Petersburg consisted of Center Street, running east–west, and Saline Street, running north–south. This postcard must have been created shortly before the electric rail tracks were built down Saline Street. The buildings in the center of the photograph still stand on the west side of Saline Street. The buildings on the far left were just past Center Street, and they are now gone. (Elizabeth Crosby Collection, Bentley Historical Library HS3544.)

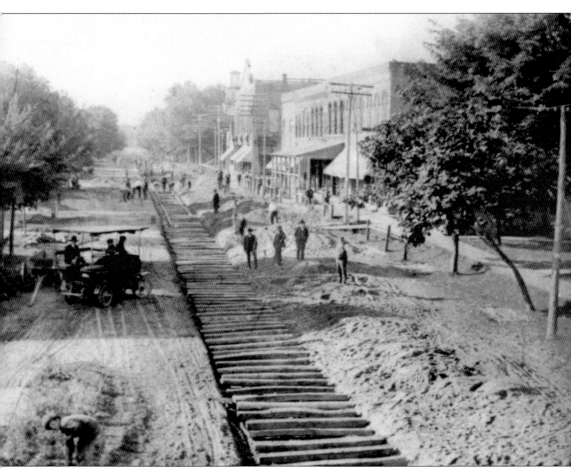

In about 1905, Petersburg was booming. The main street in town, Saline Street, is completely torn up in this photograph as workers hurry to lay new ties down the center of the street, intended for an electric trolley line. Why Petersburg? A chief investor for the project, John O. Zabel, was a Petersburg businessman. His home was just a few steps east of the scene shown here. Wood for railroad ties, steel for bridges, and other materials were stockpiled in Petersburg for use on the line to Dundee, Milan, and north to Ann Arbor. Note the car on the left, probably an electric car designed especially for the owner. In 1905, electric transportation was the big thing. (Elizabeth Crosby Collection, Bentley Historical Library HS3543.)

With the new interurban headed north in the center of Saline Street, it was to go straight across the River Raisin. Saline Street comes to an abrupt end at the river, and the new interurban plans had it going straight ahead. Huge concrete abutments were poured on each side of the river to carry the proposed interurban bridge and rails high over the water. The powerhouse was started, and as fate would have it, construction ended sometime after the concrete was poured. The half-built powerhouse was abandoned. This photograph, taken on the south side of the river, shows the bridge abutments as they appear today. (Photograph by Martha A. Churchill.)

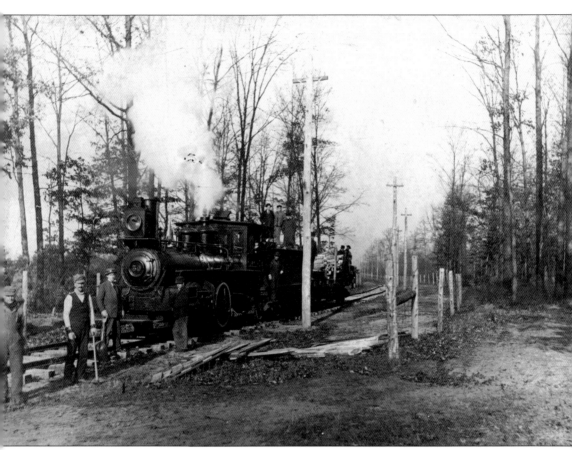

A Forney engine, No. 30, pulled construction workmen and executives through the woods south of Petersburg for an official photograph in about 1906. The Toledo, Ann Arbor and Detroit Railroad was one of several to take a hand at building this line for interurbans to connect Ann Arbor to Toledo through Petersburg. New railroad ties are loaded in the back. The railroad right-of-way is fenced. The utility poles are set fairly close together along the right-of-way to suspend the trolley wire, typical of electric interurban lines. The poles carry only two wires, which could be telephone wire or low-voltage power lines. The workmen were on the train to continue construction of the rail line. The others apparently came along to be in this momentous photograph, although the exact occasion is now lost to history. Little Forney-type engines once pulled elevated trains in New York and Chicago. (Petersburg Library.)

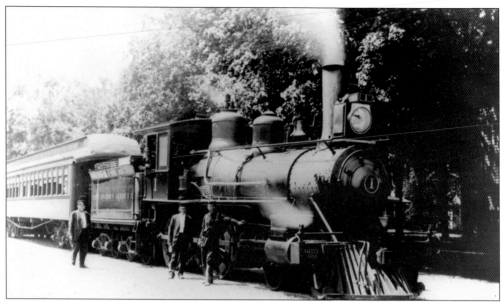

Having laid all that rail on those railroad ties from Petersburg south to Toledo, it made sense to run some trains north and south along the existing tracks. The plan was to build the rest of the tracks north to Dundee, Milan, and Ann Arbor. Meanwhile, in 1913, a steam locomotive named No. 1 worked for the renamed Toledo, Ann Arbor and Jackson Railway. The railway was nicknamed the Ragweed. Passengers appreciated the quick transportation from Petersburg to Toledo.

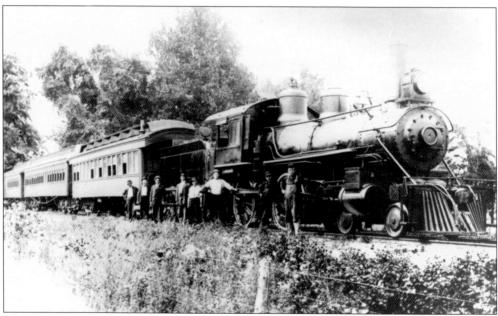

To the untrained eye, it may appear that this is the same locomotive shown in the previous photograph. However, this is a different one, and it was named No. 2. The photograph was taken in Petersburg in 1915. The railroad was built for electric rail service. Investors were disappointed when the Petersburg line was never electrified, so they used steam locomotives to generate at least some income.

Along the new interurban line, every stream, ditch, or brook had to be spanned by a bridge. Concrete abutments on either side of the stream supported the steel girders. The embankment was graded from Dundee almost to Ann Arbor. Bridge abutments along Platt Road north of Milan are still standing, especially this one in Sandra Richardson Park, just south of Willis Road. South of Milan, they were destroyed to build U.S. 23. (Photograph by Martha A. Churchill.)

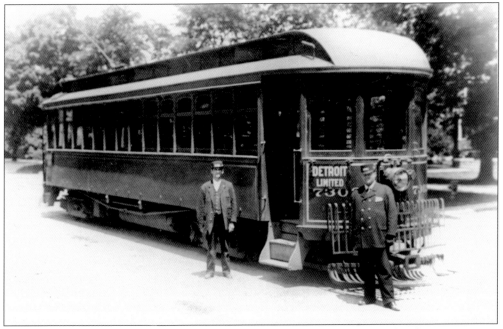

Developers for the interurban line through Milan wanted the very best for their passengers. If interurban cars had run between Toledo and Ann Arbor as intended, the cars would have looked like this one. In 1905, the developers for the line through Milan ordered cars similar to this one from the Niles Car Company in Niles, Ohio.

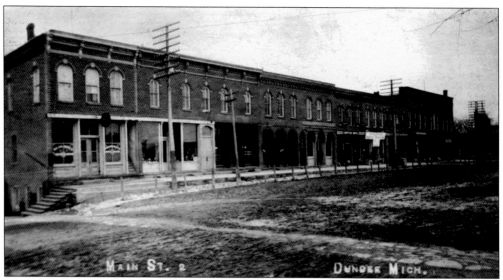

This photograph of Riley Street in Dundee was taken prior to 1908, probably right in the middle of the controversy about an electric interurban coming to Dundee, Milan, and Ann Arbor. In 1915, the Toledo-Detroit Railroad bought the Toledo, Ann Arbor and Jackson Railway line and extended it from Petersburg to Dundee. The Detroit, Toledo and Ironton Railroad operated the Toledo branch until 1965, when it was abandoned. (Postcard collection, Bentley Historical Library HS3545.)

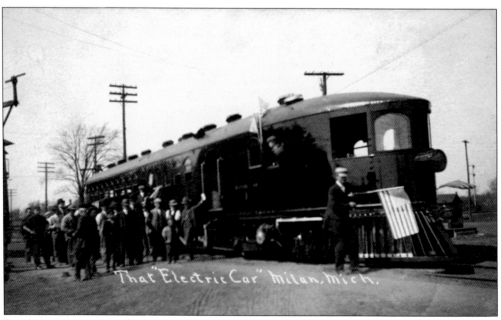

By 1911, some steam railways were threatened by parallel electric interurbans. The Ann Arbor Railway purchased five McKeen gasoline motor cars because they could start and stop quickly. Stopped at the Milan train station, a photographer jokingly wrote that it was an "Electric Car." The only person in the photograph who can be identified is railroad employee Elmer Beverly, standing in front, known as "Milan's midget." (Milan Area Historical Society.)

Seven

WRECKS HAPPEN

Interurban railways were usually side-of-the-road, single-track lines, with frequent service running in both directions. There were passing sidings every few miles. The passenger cars were usually operated according to the employees' timetable, which indicated where and when there would be a meet with an interurban going the other direction. The interurban lines in this book used a private telephone system for dispatching and did not use block signals. The company telephone wires were carried on the poles that suspended the trolley wire. At each siding, there was a telephone for the conductor to call the dispatcher. The conductor would write out what the dispatcher said and the motorman would read it back, while the dispatcher underlined the words he heard. Each crew member kept a copy, and a third copy was filed in the telephone box.

Excessive speed on a curve could result in the heavy interurban car jumping off the track. Debris on the rails, such as ice in the street, could lead the wheels not to follow the track. One of the major causes of accidents was due to animals, people, wagons, or automobiles in the right-of-way. In the country, the tracks were commonly fenced with cattle guard grates at the road crossings. Rural road crossings were not protected by watchmen or crossing gates as in the cities.

Single-truck (four-wheel) streetcars weighed five tons. Interurban cars weighed 20 to 30 tons. In comparison, a modern automobile weighs less than two tons. The energy of a moving 10- or 20-ton trolley is huge and it does not stop very fast. Early trolleys had hand brakes that forced brake shoes against the wheels. Later trolleys' air brakes were much more effective. The motorman could also reverse the electric motors to slow the car in an emergency, but it still did not stop a heavy interurban very fast. On a single-track line, interurbans approaching from both directions at high speed often could not stop in time to avoid a collision. Considering the number of interurbans run each day, it is perhaps surprising that there were only four fatal collisions between 1909 and 1929 on the Detroit, Jackson and Chicago Railway.

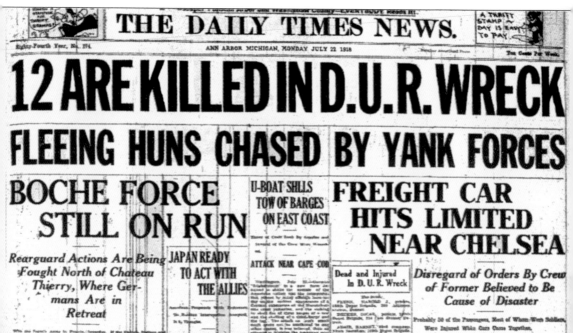

At dusk on Saturday, July 20, 1918, interurban passenger car No. 7776 and an express car smashed head-on about a mile west of the Chelsea station. The express car, No. 1936, had stopped at the Chelsea station to unload express packages. The two-man crew noticed the first westbound interurban at the station. When the crew finished unloading, it backed its car out onto the main line and headed west. It knew that there was a second passenger car coming but thought it had passed while it was working. As it rounded the corner to parallel the Michigan Central Railroad tracks, it suddenly saw the oncoming second car coming at it at 50 miles an hour. The motorman on each car slammed on the brakes, threw the motors into reverse, and jumped. The heavier express car plowed 20 feet into the 50-foot lighter wooden passenger car crowded with passengers and soldiers on leave from Camp Custer in Battle Creek. Fifteen died. The cars stayed on the track. The injured were taken to the hospital in Ann Arbor. After the bodies of the dead were removed, railway workers tipped the cars off the track and burned them. No photographs were taken. Smoldering embers and twisted steel were all that were left the next day. (Ann Arbor District Library.)

This is the view of the interurban line that the motorman of car No. 7776 had as he approached Chelsea from the west. His interurban car was crowded with passengers, many of whom were soldiers headed to Detroit from Camp Custer in Battle Creek. On the left is a freight train on the Michigan Central Railroad. The interurban line dips and rises with the terrain. Ahead is the curve behind the Methodist home that heads across Chelsea to the station on Main Street. Little did he know that an express car had left that station and was headed for the curve, which blinded him from the approaching smashup.

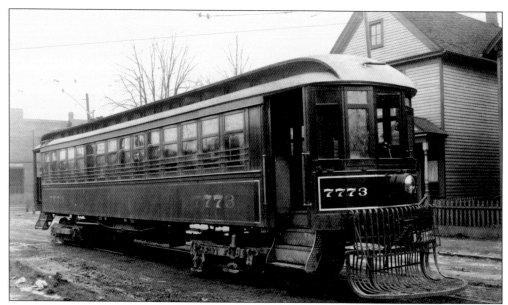

Car No. 7773 was almost identical to No. 7776, which was destroyed in the Chelsea wreck and of which there are no photographs. They both were wooden construction, built in 1901 by the Barney and Smith Car Company of Dayton, Ohio, for the Detroit, Ypsilanti, Ann Arbor and Jackson Railway. The photograph shows the third-rail shoe and ice cutter attached to the front truck for operation on the Michigan United Railway third-rail interurban between Jackson and Battle Creek.

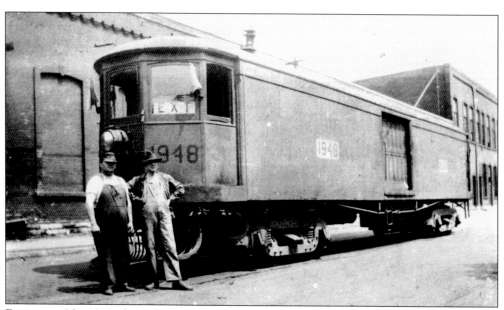

Express car No. 1948, shown here, was similar to No. 1936, which was destroyed in the Chelsea wreck of 1918. They were both built by the Niles Car Company in Niles, Ohio, in 1910 and 1911. When No. 1936 collided with the passenger car, it smashed a third of the way through the car, leading to the death of 15 passengers. The crew shown above includes D. D. Montgomery and Owen Carleton.

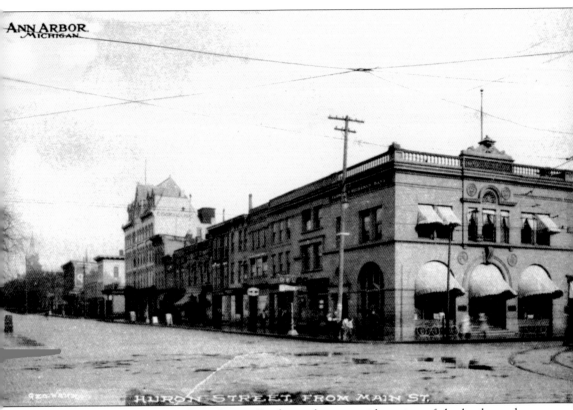

HURON STREET, FROM MAIN ST.

The story of the Farmers and Mechanics Bank wreck starts with a view of the bank on the corner of Huron Street and Main Street. The tall building at the end of the block is the Cook House, later the Allenel Hotel, which was replaced by the Ann Arbor Inn, now Courthouse Square. To the right is the curve of the interurban tracks turning from Main Street onto Huron Street, to head west to Jackson. On the night of August 4, 1927, a freight train consisting of an express car pulling four trailers loaded with sheet metal rolled through Ann Arbor at 11:30 at night headed for Jackson. A field-lead wire on the No. 4 motor of the express car was burning off due to the high demand of the Huron Street hill, so the crew left two of the trailers at the bottom of the hill. After leaving two of the trailers at the top of the hill, the crew went back and got the other two. The act of coupling the trailers together caused all four to roll back down the hill.

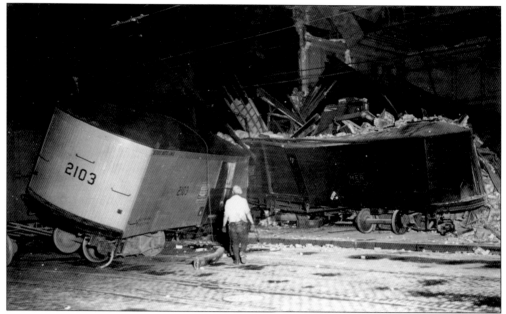

The hill is about a mile long on an almost straight track. The four trailers with nobody aboard picked up speed and were rolling really fast by the time they got to the bottom of the hill. They sped up the grade past the interurban station, and when they hit the 90-degree curve onto Main Street, they careened off the track and smashed into the Farmers and Mechanics Bank building. (Bentley Historical Library.)

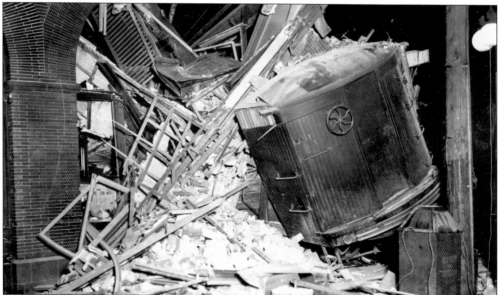

The crash occurred at about 2:00 a.m. Nobody was hurt, but the people in the coffee shop next door were shaken by the impact and the collapse of the front of the bank building. The car in the picture is the first of the trailer cars, Michigan Electric Railway car No. 1629. It was a total loss. The second car, Detroit United Railway car No. 2103, was seriously damaged. The other two trailer cars were repaired and returned to service. (Stoner Collection, Bentley Historical Library.)

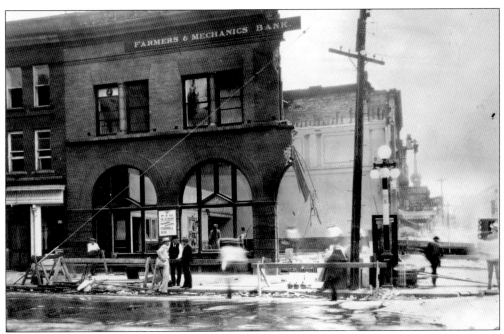

After the wreckage was cleared, the bank posted a notice on the wall that it would do business in the Cornwell building at the corner of Fourth Avenue and Huron Street, one block east. The lamppost with five globes by the telephone pole on the corner was unscathed. (Bentley Historical Library HS1621.)

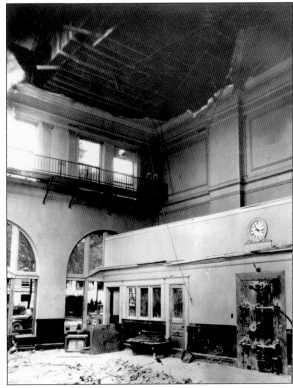

The inside of the bank building shows how much was lost—the floor, the ceiling, the windowpanes, and the entire front of the building. The bank rebuilt on the same corner with a limestone-faced building which stands today but is now clad with dark marble panels. The Farmers and Mechanics Bank became the Ann Arbor Bank, which has been absorbed into National City Bank. (Bentley Historical Library HS3169.)

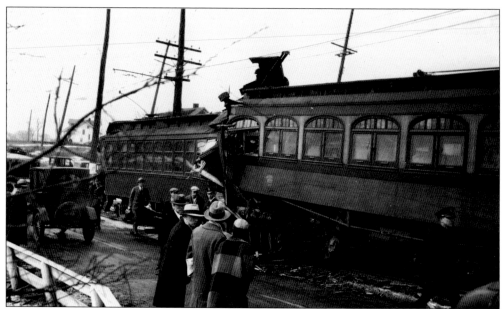

On March 11, 1928, two interurbans collided head-on just east of the Austin passing siding, one and a half miles west of Wayne. One person was killed and twenty-five were injured. Motorman Charles H. Burrows, operating car No. 7063, was headed east. He had a train order to pull into the Austin siding to permit westbound car No. 7092 to pass. He failed to do so and collided with the westbound car after passing the Austin siding without stopping.

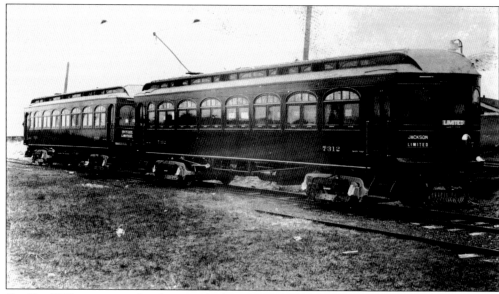

Car No. 7312 was new in the photograph above. It is similar to car No. 7092 in the Austin siding wreck. It was built by Niles Car Company of Niles, Ohio, in 1915 for every-two-hours deluxe limited service between Detroit and Kalamazoo. The trip took six hours. The third-rail shoe on the front truck was for current pickup on the third-rail section of the Michigan Electric Railway between Jackson and Battle Creek.

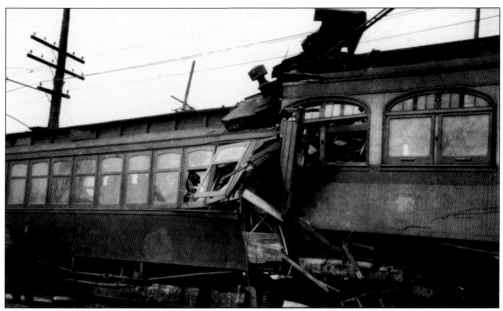

A close-up of the damage to the front ends of both cars is shown here. The newer car, No. 7092 on the right, had a steel underframe and plowed through about 20 feet of the car on the left, No. 7063. Eastbound car No. 7063 was built by Kuhlman Car Company of Cleveland in 1901. Westbound car No. 7092 was built by Niles Car Company of Niles, Ohio, in 1914.

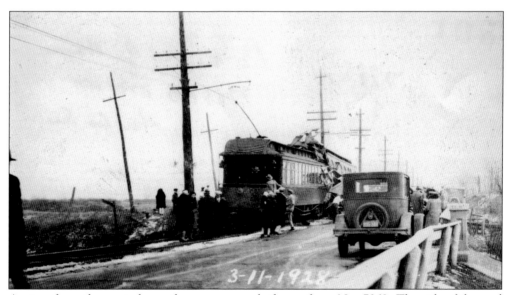

A view from the west shows the rear open platform of car No. 7063. The side-of-the-road operation of interurbans is clearly seen here. Gawkers have parked by the road to check out the accident. The stick by the tracks on the left with an angled top is a flag stop marker, indicating that the interurban would stop if a passenger were waiting.

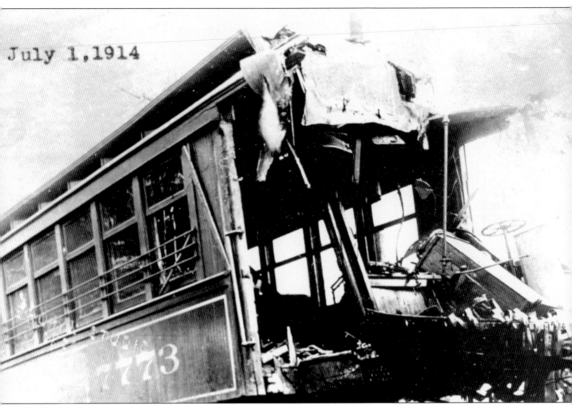

July 1, 1914

On July 1, 1914, car No. 7773 collided head-on with westbound car No. 7790 west of Michigan Center. The dispatcher had given the crew of eastbound car No. 7773 a train order to meet No. 7790 at Michigan Center, while the crew of No. 7790 had been given a train order to meet at Page siding, two miles west of Michigan Center. One passenger died and sixteen were injured. The dispatcher admitted he mixed up the passing sidings when he wrote the order, a fatal mistake. The Interstate Commerce Commission investigator recommended installation of block signals. The interurban line continued to operate by timetable and train orders.

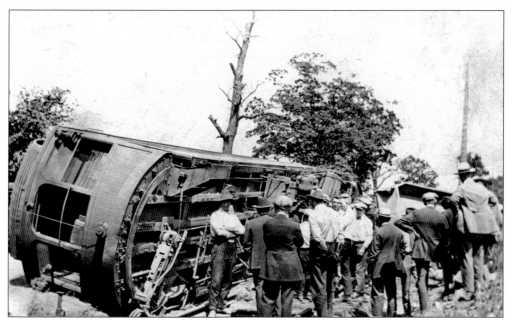

Michigan Electric Railway car No. 36 was rammed by a truck at the corner of Hewitt Road and Packard Road in 1923 and overturned. As automobiles and trucks became more common, this sort of accident happened more often. The only warning was a sign indicating a railroad crossing. Since the company was having trouble collecting enough fares to pay employees and keep up the railway, no crossing protection was installed.

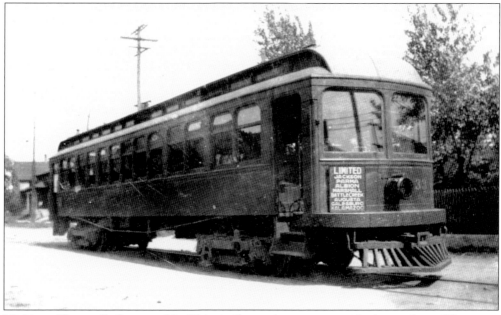

Michigan Electric Railway car No. 33 is similar to the one on its side shown above. These cars operated in limited service running through between Detroit and Kalamazoo in six hours. The sign on this car shows it operating between Jackson and Kalamazoo. Third-rail shoes picked up the electric current between Jackson and Battle Creek from a third rail rather than from an overhead wire.

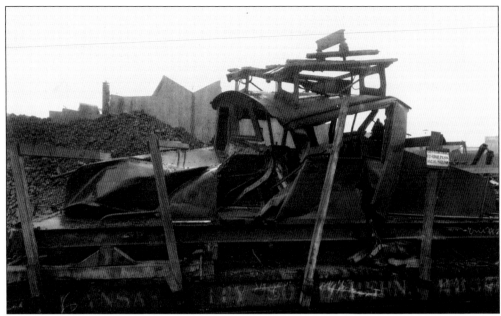

In October 1918, the repair division of the General Electric Locomotive Works received the University of Michigan 500-volt locomotive looking like this, all smashed up. From its appearance, it must have tumbled off the valley end of the University of Michigan railroad where the ashes were dumped. Perhaps someone failed to set the brakes. It is easy for railcars to roll down a grade since there is very low friction between the wheel and the rail. (Shirley Smith Papers, Bentley Historical Library.)

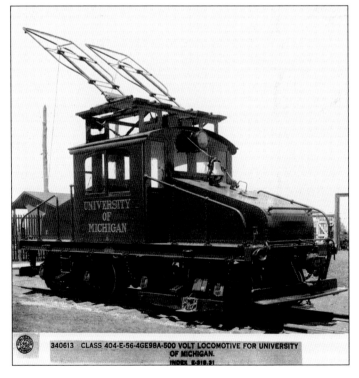

340613 CLASS 404-E-56-4GE98A-500 VOLT LOCOMOTIVE FOR UNIVERSITY OF MICHIGAN.
INDEX E-919.31

And here it is, all fixed up, shiny like new. It is hard to believe it is the same bashed up locomotive seen in the previous picture. The third-rail shoe is attached to the right front four-wheeled truck. However, the side arm pickup for the power rail on the side of the powerhouse has not been reinstalled. (Shirley Smith Papers, Bentley Historical Library.)

Eight

END OF THE LINE

In a world where horses and buggies ruled, electric interurbans burst on the scene like a firecracker. The public fell in love with electric streetcars for travel in town and the interurbans for travel to nearby communities. Travel was quick, cheap, and convenient.

During the 1890s, interurbans spread rapidly. Service spread from Ypsilanti to Saline, Detroit, and Jackson. The first years of the 20th century saw a continued expansion of the interurbans, with more cars, more stations, and more miles of track. The interurbans made money as people flocked to travel on them.

At first, a few scattered gasoline motorcars entered the dirt roads next to the horse-drawn carriages and the interurbans. Then a few more of those contraptions. As motorcars caught on with the public imagination, government followed the trend.

The State of Michigan helped kill the interurbans by using tax dollars to pave the highways for motorcars. In 1918, the voters passed a $50 million bond issue to pave roads. This provided free and subsidized roadways for those owning motorcars or operating buses. Franchises for bus operation were granted even though adequate service was provided by parallel interurban lines. Meanwhile, the electric railway companies were forced to pay taxes for the value of their interurban property. This was a double whammy against the electric railroads. No free rails. First, they had to pay for everything with private investments. Then, once the rail was laid, the companies were required to pay taxes on the value of the property, including the stations, power plants, waiting rooms, and other equipment.

The state, perhaps unknowingly, forced the electric railroads to sell their cars for scrap iron. Owners of motorcars and buses enjoyed tax subsidies, while owners of electric trolleys were taxed at every turn. The economic climate created by motorcars made it impossible for interurban companies to survive, make a profit, and pay back their investors. In the 1950s, a consortium of bus makers, tire makers, and oil companies bought some streetcar companies to substitute their products.

Interurbans survived in Washtenaw County until the late 1920s, when streetcars turned out the lights and interurbans locked the door on the way out. It was the end of the line for electric trolleys.

Detroit, Jackson & Chicago Railway—Cont'd.

WEST BOUND—DETROIT TO JACKSON—Local Trains—Continued.

5 00	5 30	6 00	6 39	7 00	7 30	8 00	9 00	10 00	11 00	
5 25	5 55	6 25	6 55	7 25	7 55	8 25	9 24	10 25	11 25	
5 47	6 17	6 47	7 17	7 47	8 17	8 47	9 47	10 47	11 42	
6 09	6 39	7 09	7 39	8 09	8 39	9 09	10 09	10 10	11 09	11 58	12 00	
....	7 10	8 10	9 10	10 43	12 28	

The Detroit United Railway issued *The Official Electric Railway Guide* in July 1908, complete with advertisements for just about anything an interurban passenger might want to buy. Railway schedules were mixed in with advertisements. This section of the guide shows two advertisements next to each other, one for a company that made carriages for horses, the other for a garage in Ann Arbor that fixed gasoline-powered motorcars. It was a changing world.

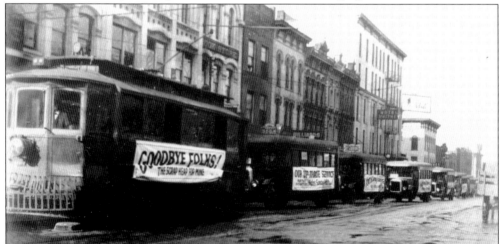

A lonely streetcar makes a final trip, covered by a sign reading, "Goodbye Folks! The scrap heap for mine." A line of new buses follows behind past the Hotel Whitney on Main Street in downtown Ann Arbor on January 31, 1925. Each bus is decked out with a sign boasting about the up-to-date service they would provide. (Bentley Historical Library BL000325.)

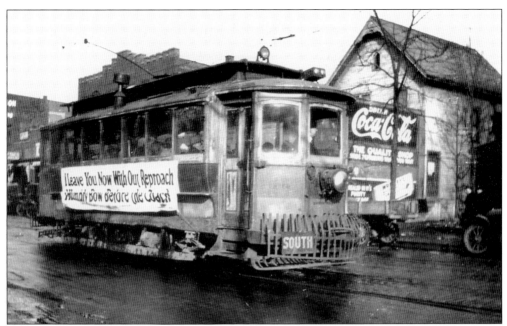

Strains of funeral music blasted from the windows of this streetcar as it made the last ride down Main Street in Ann Arbor before becoming scrap metal. The public reacted to the end of the streetcars with a carnival-like attitude. Someone placed a sign on the streetcar: "I Leave You Now With Out Reproach, I Humbly Bow Before the Coach." (Bentley Historical Library.)

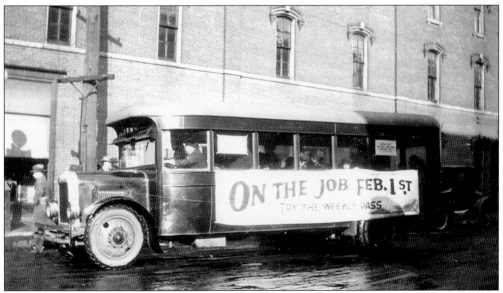

On January 31, 1925, buses took over the job of the electric trolley for a one-year trial. Fewer people rode the bus, but the trolleys were gone for good. The bus shown in this photograph pulled up beside a building in Ann Arbor with a prominent banner advertising its services. (Bentley Historical Library.)

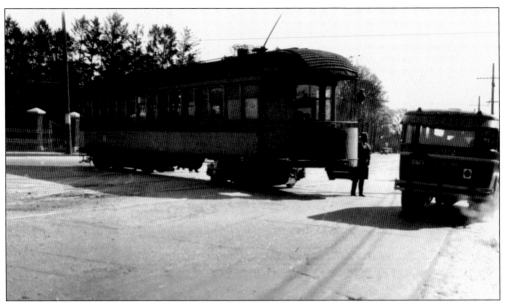

Competition between the electric interurban and the gasoline-powered motor bus reached a fever pitch in this scene. On May 6, 1929, the Detroit, Jackson and Chicago Railway car No. 7792 was derailed at Nowlin Street on Michigan Avenue in Dearborn. The bus, operated by the interurban company and spewing fumes from its tailpipe, calmly drives around the stranded trolley. They did not know it at the time, but the bus was pushing the interurban into extinction.

A new motor bus pulls up to the Ann Arbor Savings Bank building on the northwest corner of Main and Huron Streets in Ann Arbor in 1930. Most people at the time still remembered the electric streetcars from five years previously, but the public quickly accepted the bus system as appearing more modern. (Sam Sturgis Collection, Bentley Historical Library HS1706.)

For a while, the interurban station in Ann Arbor survived, including the tower, after the interurbans stopped. This photograph of the bus station shows a Blue Goose Lines eastern Michigan motor bus on the right and a motorcar on the left, while someone stands at the curb waiting for a ride. The tower stood as a reminder of the building's former use as an electric substation. (Bentley Historical Library.)

In 1940, Ann Arbor lost its interurban station when this new art deco–style bus station replaced it on the same site. Buses could enter it from the rear and unload and load under the covered area, although more recently the newer buses are too high. Only a few intercity bus runs serve Ann Arbor anymore, a far cry from the 40-per-day interurban runs. (Photograph by Martha A. Churchill.)

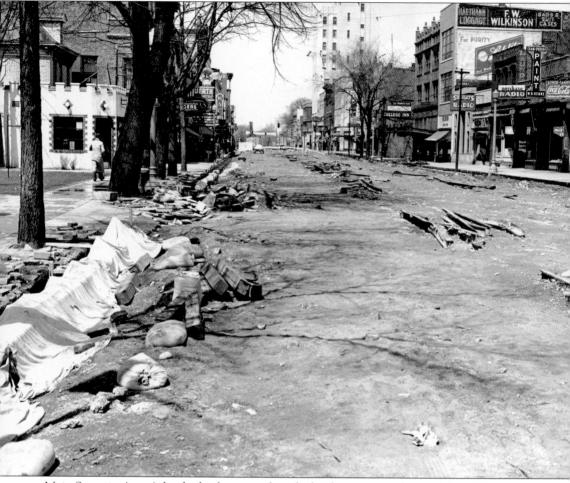

Main Street in Ann Arbor had to be repaved, so the bricks were ripped up and the old interurban rails torn out. The year was about 1942. Photographer Eck Stanger of the *Ann Arbor News* stood in the street, near William Street, facing north toward Huron Street. It so happens Stanger lost his father on the Chelsea interurban wreck in 1918 (see chapter 7). On the left in this picture, a hamburger joint is seen with a crenellated top. It still stands as a restaurant today. Jumbled rails are exposed in the center of the street, left over from a time when double tracks served the downtown. On the right, a switch lies in the middle of the street. Soon the street will be repaved, not with bricks, but with modern materials. (Bentley Historical Library vertical file HS3685.)

Cities with streetcars had a lot of work to do removing miles of track from the streets. In Ann Arbor, workers dig out the old rails in about 1942 on Catherine Street. This photograph shows an area where the single tracks split into double track. A sign over the sidewalk advertises Sealtest ice cream and milk in the Ann Arbor Dairy building. This building was later demolished for a parking lot. (Bentley Historical Library HS3541.)

Which is harder, laying rail or pulling it out? The workers in this photograph would probably point out how difficult it is to remove rail from a street. In 1942, Ann Arbor was motivated to get the rails removed from Catherine Street so the scrap metal could be used in the war effort. (Bentley Historical Library HS3537.)

The Ann Arbor Construction Company power shovel seems to lift the entire pavement along with the old rails from the electric interurban lines. It looks like Michigan Avenue in Ypsilanti is closed while this is going on. Fewer people chose to ride the electric railway after World War I. After 1921, the Michigan State Public Utilities Commission restricted fare increases. When the system closed down, there was nothing left to do but let the city remove the rails. (Ypsilanti Historical Society.)

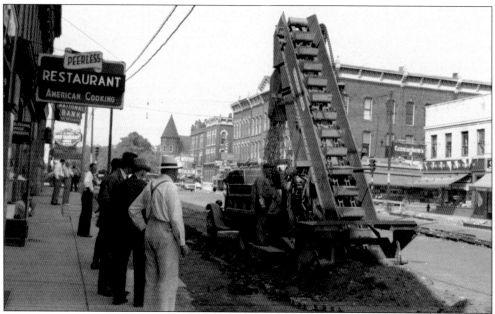

A loader scoops up debris from the brick pavement on Michigan Avenue, just east of Washington Street, in about 1943. The old rails from interurbans and streetcars had to be removed from the pavement. Onlookers stare at the progress in front of the Peerless Restaurant. Cunningham's Drugs is across the street on the corner, and the conical tower of Cleary College can be seen in the distance. (Ypsilanti Historical Society.)

With the interurbans and streetcars gone, the Detroit, Jackson and Chicago Employees' Association held reunions every winter and picnics every summer. Two men were photographed at a picnic in Prospect Park on August 11, 1946. The one on the left is Floyd Maxwell, who switched to selling insurance and tires in Dearborn when the electric trolley lines went cold. As a hobby, he collected photographs of interurbans. The man in white, Alfred Augustus, helped organize the reunions. (Ypsilanti Historical Society.)

Conductors, motormen, shop workers, and even the executives loved the annual reunions. These men all worked at one time for the Detroit, Jackson and Chicago Railway, a division of the Detroit United Railway. Most of them brought wives, who gathered for a similar mass photo shoot. The date was August 17, 1941. The place was Prospect Park in Ypsilanti. One or two of these men may have started as operators of horse-drawn streetcars and transferred to interurbans. (Ypsilanti Historical Society.)

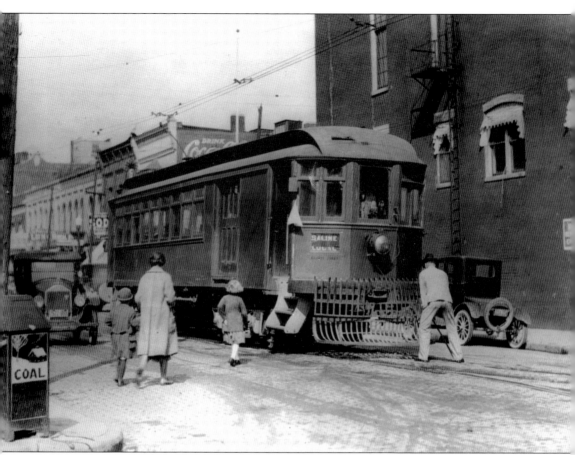

The Saline shuttle car, known as *Old Maud*, stands in front of the interurban station on Washington Street in Ypsilanti for the last time. Two children, followed by their mother, head toward the big trolley. *Old Maud* has rolled into town on Michigan Avenue, then backed into Washington Street on the curved track in front. A switchman is standing to the right of the car using a switch iron to flip the track, allowing the car to roll back onto Michigan Avenue and head west to Saline. This was the last trip for *Old Maud*. This picture was taken on September 27, 1925, the last day Saline had interurban service. The State of Michigan wanted to widen and pave Michigan Avenue, helping the gasoline-powered motorcars. This had to be done at the expense of the Detroit United Railway, the operator of *Old Maud*. The railway company had built the railway in the highway right-of-way. Now it was ordered to move its rails, or else. There was no money available to move rails, so the line was abandoned. It was the end of the line.

BIBLIOGRAPHY

Central Electric Railfans' Association. *Electric Railways of Michigan.* Bulletin 103. Chicago: Central Electric Railfans' Association, 1959.

Hilton, G. W., and J. F. Dew. *The Electric Interurban Railways in America.* Stanford, CA: Stanford University Press, 1964.

List of Electric Railway Companies in United States, Canada and Mexico, February 1915. New York: McGraw Publishing Company, 1915.

Meints, G. M. *Michigan Railroads and Railroad Companies.* East Lansing: Michigan State University Press, 1992.

Murphy, Nancy K. *History of Public Transit in Ann Arbor.* Ann Arbor, MI: Ann Arbor Transportation Authority, 1987.

Schramm, J. E., W. H. Henning, and R. R. Andrews. *When Eastern Michigan Rode the Rails.* Book 3. Glendale, CA: Interurban Press, 1988.

Shackman, Grace. *Ann Arbor in the 20th Century: A Photographic History.* Charleston, SC: Arcadia Publishing, 2002.

U.S. Department of Transportation. *Interstate Commerce Commission: Investigations of Railroad Accidents 1911–1993.*

Ypsilanti Historical Society. *Combination Atlas Map of Washtenaw County, 1874, 1895, (1915).* Mount Vernon, IN: Windmill Publications, 1991.

ACROSS AMERICA, PEOPLE ARE DISCOVERING SOMETHING WONDERFUL. *THEIR HERITAGE.*

Arcadia Publishing is the leading local history publisher in the United States. With more than 3,000 titles in print and hundreds of new titles released every year, Arcadia has extensive specialized experience chronicling the history of communities and celebrating America's hidden stories, bringing to life the people, places, and events from the past. To discover the history of other communities across the nation, please visit:

www.arcadiapublishing.com

Customized search tools allow you to find regional history books about the town where you grew up, the cities where your friends and family live, the town where your parents met, or even that retirement spot you've been dreaming about.